W9-CKU-159

AN ARTIST'S NOTEBOOK
The Life and Art of Merritt Mauzey

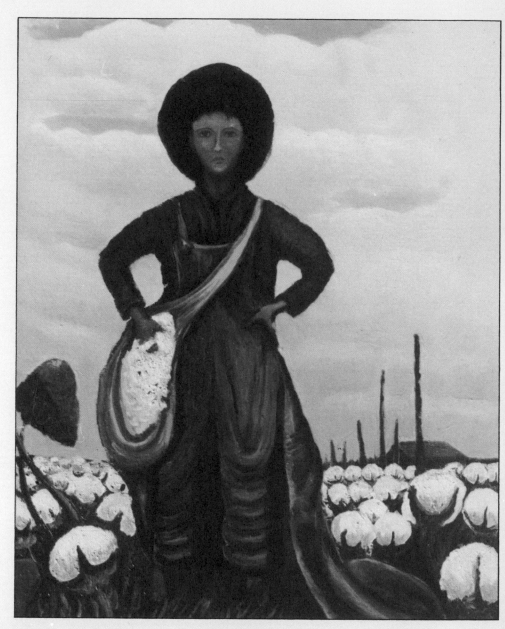

MEMPHIS

Memphis State University Press
Memphis, Tennessee

AN ARTIST'S Notebook

THE LIFE AND ART OF MERRITT MAUZEY

Edited,
and with a Foreword by
Gordon Weaver

with the editorial assistance of
Warren Tracy

ISBN 0-87870-066-8

This is dedicated to Jess and a dream.

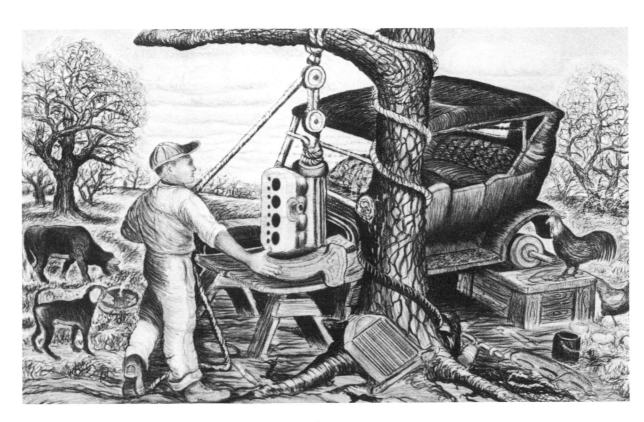

Jess

Contents

List of Illustrations

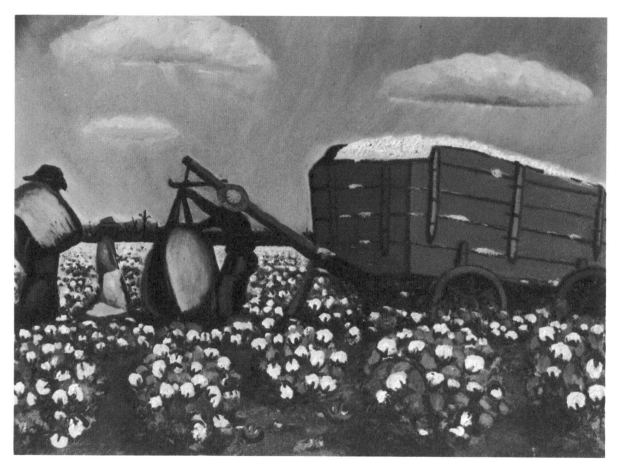

Cotton Pickers

Foreword by Gordon Weaver

There is not a great deal that needs to be said in introducing the work of Merritt Mauzey to the reader. The examples of his art contained in the pages that follow are their own eloquent statement; they need no elaboration (art never does), and certainly they require no superfluous praise—Merritt Mauzey's achievement was widely recognized during his lifetime, as the accompanying chronology testifies. Nor is there any compunction on the editor to greatly extend the biographical information the artist offers in his literary sketches—this book does not pretend to be a formal autobiography.

Merritt Mauzey saw himself, as his art and his writing indicate, without pretention. His father, Henry Clay Mauzey, was born in Bowling Green, Kentucky, the family tracing its origin to the town of Mauzey, France. His mother, Amanda Elizabeth Crowe, was born near Meridian, Mississippi. They married at Alma, Arkansas, where the artist's father was a school teacher. Merritt Mauzey was the youngest of nine children born to them.

It is characteristic of the tone of the artist's autobiographical writing that he should more than once speak of himself as a "black sheep," a man from a family "without family records." Yet, though he claimed no special distinction in his lineage, he wrote of his life-long concern to avoid blemishing, in any fashion, the "untarnished family's name," and his love of family is seen in the dedication of his autobiographical writings to his brother, Jess.

The editing of this manuscript has been done with a cautious hand. It is not *literary* biography that Mauzey intended, but a straightforward series of sketches to serve as background to his work in graphic art. Consequently, the task of the editor has been minimal, with changes being made solely to avert repetition, and to more directly match the illustrations to the text. The only editing of Mauzey's style was to insure literary regularity and yet still retain his meaning.

What emerges from the artist's words, complementing a quality consistently evident in his art, is the decidedly *American* character of both the man and his art. Merritt Mauzey's lithography and oils record an American subculture that has almost wholly passed from the national scene; it can be argued that the special character of a man like Merritt Mauzey, produced by that culture, is equally rare in America today. The reader is alerted to watch for this quality in the words and pictures that follow.

Mauzey's roots were rural, and thus his view of the world around him is direct, unadorned, not without genuine feeling, but certainly untainted by emotionalism or self-serving subjectivity. The same can be said of the quality of rural life that is the theme of his art. Mauzey's writing is almost always underlain by a sincere spiritual awareness, but never clouded by a cheap or noisy piety. Most important, the depth and breadth of his attachment to the very texture of the way of life he recorded in art is so pervasive as to constitute a quality in the artist—and the man—himself; there is an essentially wholesome earthiness, a devotion to concrete reality, in the words and pictures that is disarming, sometimes refreshingly surprising, to a reader who does not share the artist's roots in an America that is fast now becoming parody in art and cliché in literature.

More generally, the life of Merritt Mauzey expressed in these sketches fits the classical paradigm of the American artist. He is rural in origin, born to circumstances that would discourage a life in art, born, in short, to confront enormous obstacles in the pursuit of his art. But the vision, the *Ideal* of art persists, and the obstacles are overcome—not without tremendous personal sacrifice. The parallel of this pattern with that of the Horatio Alger mythology (the mercantile counterpart of the myth of the Artist) breaks off, of course, as it inevitably must. There are no riches at the end to reward the artist.

In the mercantile world, riches are the reward (or so, at least, Horatio Alger's experience would promise) of work; in the artist's life, the *Work* is the reward of work—the Ideal is realized in the art produced in pursuit of the Ideal. This is all manifest in the pages

that follow. In the juxtaposition of word and picture, the reader has before him the shape of Mauzey's vision of the Ideal and the substance of the craft that went to realize it.

There are a number of admirable elements in the artist's life we present here; the intense dedication to his dream, the sheer expense in human energy required if he is not to fail that dream, and the strength of character that enables the artist to continue unstinting in a relative obscurity and isolation that would surely flag the spirit of lesser men. All are visible to the reader in the example of Merritt Mauzey.

I never met Merritt Mauzey. I admire his work, and I feel sure I would have liked him personally. Merritt Mauzey was not unsophisticated; he well knew the reality of his gift as an artist—he had, after all, earned that gift through the difficult discipline of his craft. But he also recognized the assistance of those friends and patrons who gave aid and comfort when it was so sorely needed. A list of those whom Merritt Mauzey wished to acknowledge includes: Dr. Irvin Kerlan, The University of Minnesota; Dr. Warren Tracy and Dr. Lena de Grummond, the University of Southern Mississippi; Mrs. Orrline Shippey, Director, the Nicholson Memorial Library, Longview, Texas, Friends of the Library, and the Junior Service League; Mr. John R. Vincent, Director, The Museum of the Southwest, Midland, Texas, and Mr. and Mrs. William Marshall and other friends of the museum; Mr. H. Paul Kotun and the Accession Committee, Washington County Museum, Hagerstown, Maryland; Mr. Joseph Feher, Curator of Graphics, Honolulu Academy of Arts; Miss June Keller, Switzerland; Mr. and Mrs. Charles D. Clark; Dr. William Potts; Miss Edith McRoberts, Dallas, Texas; the late Mr. William L. Clayton; the late Mr. Armsted Brooks; Luise Putcamp, Jr.; Dr. Jacob Kainen, Curator of Prints and Drawings, and Dr. Joshua C. Taylor, Director, National Collection of Fine Arts, Smithsonian Institute; The John Simon Guggenheim Memorial Foundation; Mr. Carl Zigrosser, Curator, Print and Drawings, Philadelphia Museum; Peter W. Guenther, Associate Professor of Art History, University of Maine; Professor Vincent A. Hartgen, Head, Art Department, University of Maine; William R. Best, Director, Thomas Gilcrease Institute of American History and Art, Tulsa, Oklahoma; Decherd Turner, Librarian, Bridwell Library, Southern Methodist University; Mr. and Mrs. Harris Underwood; Mrs. Myrna Verner; Mr. Troy Myers; Dr. Black, Dr. Eugene Kingman, and Dr. Grover Murray, Texas Tech University; Mr. John I. H. Baur, Director, and Elke M. Solomon, Associate Curator of Prints, Whitney Museum of American Art.

The character of Merritt Mauzey, the man, is indistinguishable from the character of the artist and his art. The juxtaposition of word and picture in the following pages will demonstrate this better than any testimony, but the essence of that character is perhaps best summarized in the words of one who knew him best as man and artist. His son, Merritt Mauzey, Jr., Senior Vice President and Cashier of the Merchants State Bank, Dallas, Texas, writes of his father: "My father's art was created at great sacrifice—drawing at night after ten hours of work during the day, six days a week . . . Almost every other year he was hospitalized . . . He wanted to use his God–given talent to contribute something to the world . . . He gave away as much art as he sold . . . He always said he would rather 'wear out than rust out' . . . He certainly did not rust out."

It is necessary to acknowledge the roles played by Dr. Lena de Grummond and Dr. Warren Tracy of the University of Southern Mississippi in establishing, assembling, and organizing the extensive collection of Mauzey's artistic and literary materials for the University's library. The comprehensive *Catalogue of the Merritt Mauzey Collection*, prepared by Dr. Tracy, was published by the University of Southern Mississippi in 1972.

Gordon Weaver
Oklahoma State University

AN ARTIST'S NOTEBOOK
The Life and Art of Merritt Mauzey

Self Portrait

Introduction

At the beginning of the Twentieth Century demand for cotton greatly increased. The need for more land drove cotton farmers westward, where they invaded cattle, goat, and sheep ranching country.

During this period, horses and mules furnished the power for tilling the soil. Farming required hand labor for chopping and picking the cotton. The farmer depended upon rain for moisture in growing his crops. Before the middle of the century irrigated cotton farming came into being, and mechanized equipment replaced the horses and mules, reducing hand labor on the farm.

Much of my art has been an effort to document this period, which I call the "last frontier of the dry–land cotton farmer."

I have written this narrative, thumb–nail sketches of people I love, but their names have been invented. My hope is that *An Artist's Notebook* will broaden and deepen the scope of the subjects treated in my art, giving my audience the often mundane, but always substantial details of this way of American life in the years between 1897 and 1927.

I admit my prejudices here. I'm allergic to much of the Tuxedo Society, a great part of which seems to me to be artificial. I have always declined invitations to Black Tie events.

I have tremendous admiration for Presidents Lincoln and Eisenhower, but I am a progressive Democrat; I feel the party represents more of our country's poor, and I have always been one of them.

I joined the Methodist Church under a brush arbor in west Texas while a youth. I have been a member since. Nothing which I have created could have been accomplished without prayer.

Grove Meeting for Men

Brush Arbor

1
Early Impressions

I was born November 16, 1897, at Clifton, Bosque County, Texas, the youngest of nine children. I had a gnome–like figure, all head, small body and spindly legs. I was sickly, with chills and fever, which caused my family to doubt my survival. But my early experiences were etched so deeply on the scroll of my memory they have remained with me all through life.

One early memory, vivid as if it were yesterday, is of going with my mother to the Everett Ranch, where its owner, Jess Everett, lay in death, having been struck by lightning. Somehow, the mystery of death hovered about. Adding to its presence, a strutting pea fowl in the barnyard was making rhythmic drum–beat noises, uttering the most mournful and unearthly sounds that I had ever heard.

Another early experience with death came after listening all night to a lonesome wind rustling leaves on a mesquite tree near our house. I was too young to know the meaning of death, but it was no surprise when my parents told me the next morning that my sister, Ida, was dead. The sign of the wind and the night had told me.

I was, and have always been, an extremely sensitive person. Often, through some mysterious source, I have been forewarned of impending sorrow and tragedy, which has mercifully conditioned me to its shock. This same sensitive perception has lifted me to a grand feeling of ecstasy long before being notified that a dream has come true.

Born on the soil and living off the earth's bounty drew me close to nature and to nature's creatures.

Whippoorwills flying at twilight made a noise like a rock thrown from a slingshot. I thought they were throwing stones hidden beneath their wings. I called the bird a "bullbat."

The sight of killdeers nodding and teetering around ponds carried me into a never–never–land. I called the bird a "killdee." I knew the meadow lark as a "field–lark," fly catchers as "scissortails," and cardinals as "red-birds."

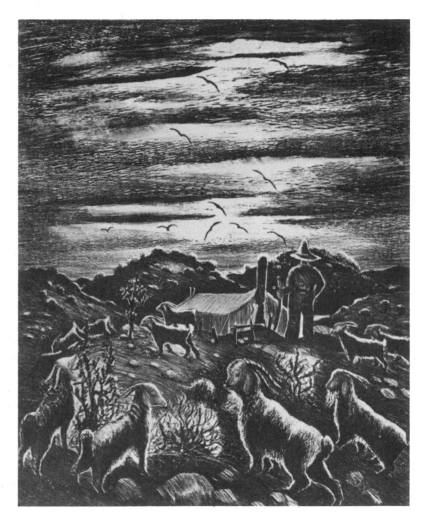

Whippoorwill's Song

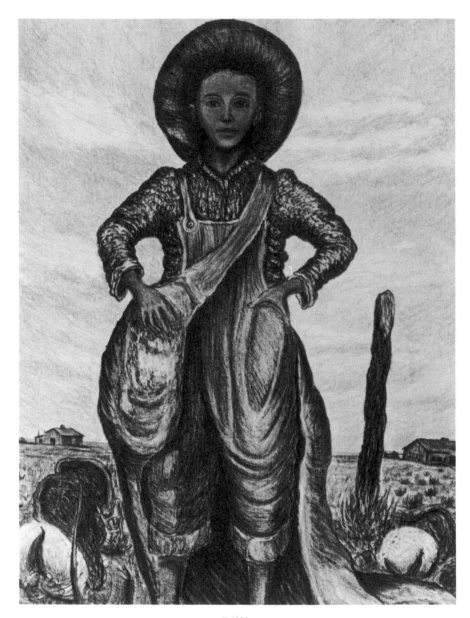

Billie

4

My name for "poison ivy" was "poison oak" and "yucca" was "bear-grass." "Fireflies" were "lightning bugs." The cicada, an insect of the locust family which makes a prolonged rasping noise on hot summer days, was a "dry-fly" in my vocabulary. The "dragonfly" was a "snakedoctor."

Earth worms were divided into two groups, "grub-worms" and "redworms." A worm which appears to be taking the measurement of vegetation as it reaches out and folds its body like an accordion was a "measuring worm." A worm which expectorated a tobacco-like liquid was a "tobacco worm." I supplied the names I did not know.

Perhaps a botanist can supply the correct names for what we called "alkali weeds," "careless-weeds," and "threadsath," or the proper name for a vine which we called a "possession vine."

Some old timers called a turtle dove a "turkel dove." It was a deadly sin to kill a dove or mockingbird. I was thirty years old before I killed a dove, and still have qualms about killing one.

Mockingbirds in west Texas have a different list of songs from those in east Texas.

Our family ate curlews until we saw them extracting spiders from holes around water ponds. Nature fashioned the bird with a bill suited to the purpose.

My brother, Jess, and I lived the typical life of farm boys of that time. We watched bees make a beeline from watering places and followed their course to bee trees loaded with honey.

We found wild turkey roosts and awaited their coming in to roost at sundown.

I felt guilty when we robbed a wood-rat's den of pecans. In the act we caught two young squirrels. We made them pets, and I also caught something else. By the time I was relieved of the horrible maddening itch from poison-oak, I was almost a lunatic; it caused me to remember Brother Bates saying, "The wages of sin is death."

Although we had empathy for all wildlife, through necessity we trapped badgers, civet, coyotes, skunks, opossums, and wildcats.

We shipped our furs to F. C. Taylor and Son, and to Funston Brothers, both of St. Louis, Missouri.

In our boy's world we ate wild currants plucked from bushes in Oak Creek bottom, and water cress gathered along the water's edge. The prairie held many delectables to satisfy our inquisitive minds as well as our appetites. We ate sour-sweetish pods from devil's-pincushins and prickly pears; sweet berries from thorny agerita bushes; almond flowered seed from catclaw and Devil's-spur; and seed from mesquite beans which had the flavor of well ripened persimmons.

Our digestive systems, equal to those of boa constrictors, allowed us to eat crow-poison (wild onion) without harm. Naturally our name for the wild vegetable added much to the experience.

We were impatient for peaches to ripen, and often ate them half matured. Discomfort from the hard peaches caused bad dreams, but didn't teach us not to eat pecans in the same state of maturity. We stained our hands yellow in hulling the nuts, and the cathartic of the green pecans often drove us in the middle of the night to the two-holer.

The gifts of nature were many. Chewing gum presented no problem, for we manufactured our own from wax which oozed out of cedar, chittum, and mesquite trees.

My imagination was without limit. I thought by going far enough west I would come to the end of the earth. I believed that toad frogs caused warts, horned toads could spit blood, and that if a terrapin clamped its jaws on one of my fingers it would have to thunder before it would turn loose.

I could see a pot of gold at the foot of a rainbow and the old devil with his horns and forked tail was as visible to me as the stick horse which I rode.

I saw ghosts around graveyards; fox fire in Oak Creek bottom was ghosts on the prowl. I was afraid of the dark.

Although at times my imagination caused needless fear, my boy's world was so filled with delightful fantasy that I was reluctant to give up its magic years.

Some grown-ups said canned salmon was canned bullsnakes and I couldn't eat salmon for years . . . I couldn't eat grape jelly or beets for they made me think of blood.

I imagined that I was being mistreated and ran away from

home several times, but never got further than Oak Creek, a mile away.

I had a lot of dreams . . . I wanted to be a sheepherder and, of course, a cowboy. Upon seeing my first locomotive, I wanted to be a locomotive engineer. Watching men in uniform playing in a brass band, I wanted to play in a band. I have always loved music and work best by music, but I have never been able to carry a tune, so that dream didn't work. After reading *Robinson Crusoe* two or three times, I wanted to be a sailor.

To impress a certain girl, I wanted to be a bronc rider, so I trained for the profession by riding our calves when the family was away.

One dream would never go away. I wanted to be an artist, and the dream came true.

"Look," they said, "unto the rock whence ye are hewn, and to the hole of the pit whence ye are digged."

With these words from the Bible, the film of memories rolls, and as it moves a little of the rock and hole and pit are revealed.

6

2
The New Country

At the turn of the century my family heard about a country to the west with gentle hills clothed in cedar and wide unspoiled prairies and rich valleys set in mesquite trees without number. Cottonwood, elm, willow, and pecan trees lined its water courses. Chittum, hackberry, sumac (shumake), prickly pear, bear-grass (yucca), and other growth were scattered between motts of live oak, post oak, and Spanish oak in the vast region.

In springtime, scarlet pods on prickly pear, masses of snow white plumes on tall stems of bear-grass, and immense carpets of wild flowers of various colors were engulfed in an emerald sea of gramma and mesquite grasses. Underneath azure blue skies spring zephyrs swept nature's fragrance across a land of unequaled beauty. The new country was a poet's dream and an artist's paradise.

The virgin soil which had never been ripped apart with a plow filled the dream of countless farmers. To hundreds like my family, who dreamed of a home in a new country, it was their promised land.

The recollection is not nostalgia, for there is nothing firm about nostalgia, nor is the remembrance only a dream; a country existed in its pristine state to fill the need of a time. The need began when the cotton gin was invented by Eli Whitney in 1793. After the gin was invented the demand for cotton grew, causing its growth to spread until there wasn't any new land on which to grow cotton, and the demand continued.

At the end of one hundred years, the Great Designer had a plot already drawn on the blue print of time, vast acreages in western Oklahoma and west Texas suited to dry land farming.

The territory was being grazed by ranchers, but the ranches gave way to agriculture, providing a last frontier for the dry land cotton farmer. It had been only a few years since Indians and great herds of buffalo roamed the land. The buffalo had been slaughtered and the Indians subdued, yet a great transition continued due to the invasion of farmers.

An exodus from Bosque County began in 1898, when some of our neighbors moved to Fisher and Taylor counties, and my sisters, Theo Lanier and Jennie Whitt, with their husbands, moved to Runnels County; my sister, Maggie Sedberry, settled in Nolan County with her husband; all of these places were part of the new farming country.

In 1900, my parents, my unmarried sisters, Ida and Gertrude, and my brothers, Albert, Comstock, and Jess, and I moved in a covered wagon two hundred and twenty-five miles and settled in Oak Creek Valley in Nolan County. After we arrived Albert made a wagon trip back to Bosque County and brought the remainder of our household things and farming tools to our rented farm.

When Texas was new, the state set aside land for development of schools and gave railroads land as an incentive to build their lines into the thinly settled country. Ranchers leased the land from the state and railroads on which to graze their livestock. Much of this land was for sale.

In 1902 we bought a quarter section (160 acres) of railroad land which lay at the foot of cedar covered hills on the east side of Oak Creek Valley. Our farm was two miles east of Decker, where Asa Ross and Henry Shafer had general merchandise stores. Mr. Moore had a blacksmith shop and Mrs. Prim a road stop for traveling men. The Decker postoffice was in Shafer's store. The Decker schoolhouse, which was used as a church building as well, was located one-half mile north of the two stores.

Like many villages of that time, all that now remains of the public buildings is the church house.

When we arrived, fortunes had been made out of the sale of barbed wire; tons and tons of it were being strung alongside new farms and lanes to new roads. Fencing the farms and lanes required thousands of fence posts.

His first name has been lost, but Leander, his surname, remains firm on the film of my memories, and his weathered

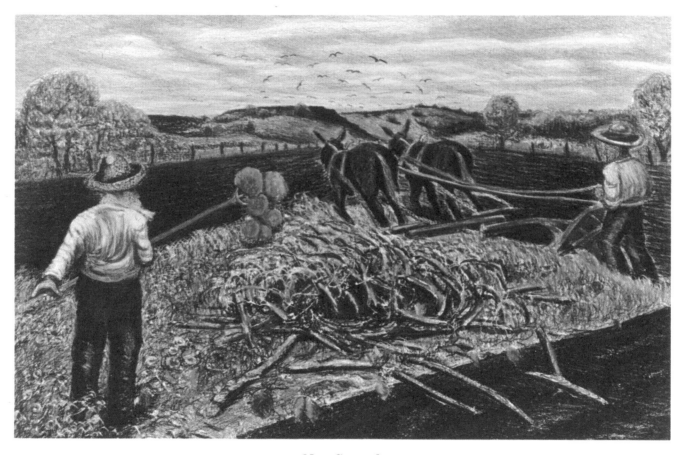

New Ground

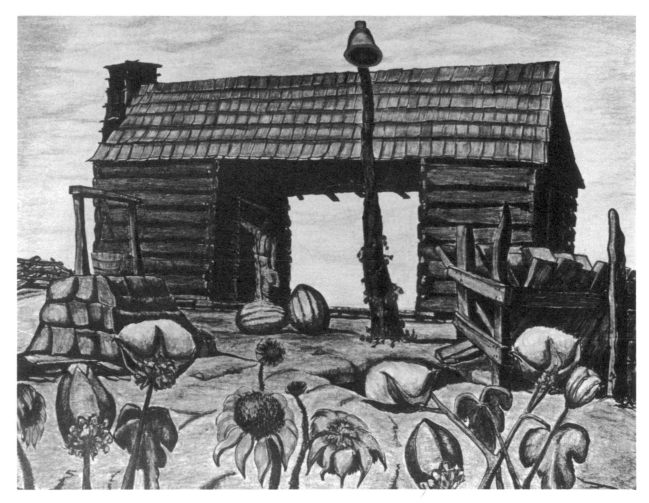

Southern Memories

9

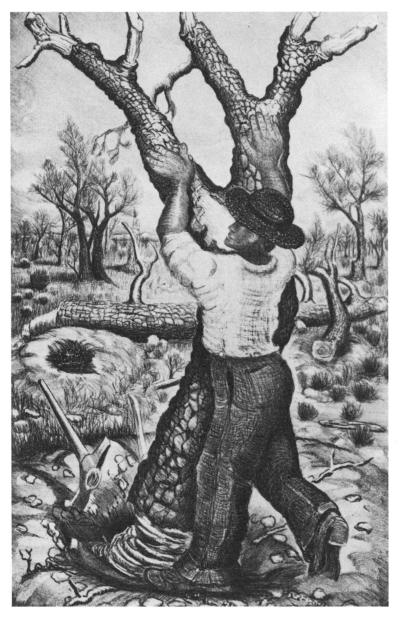

Bob Smith, Grubber

appearance and contented look stand out in bold relief. Leander, an old bachelor, with his axe as a companion, and a tent for shelter, lived what would seem to most people a very lonely life in the cedar brakes, cutting posts for a living. This old "cedar-whack," a name which his profession bore, had the same look of contentment sheepherders seem to have.

I have often wondered, with some envy, about the dreams which would give anyone such a contented look.

In the Decker settlement, Bob Smith, a big muscular man, grubbed trees and cut them into fence posts and cord-wood lengths. He sold the cord-wood for fuel, the posts for fencing purposes. Like other grubbers, Bob earned his living through the sale of cord-wood and posts.

Due to the haste in fencing, many trees were cut down to secure posts. This left a stump in the earth, and before the land could be plowed the stump had to be removed. The stumps were grubbed out of the ground by some settlers; Preston Dunn used his horsepowered stump puller in the Decker settlement for those who wished his service. After the trees were grubbed and stumps removed, brush and other residue were placed in piles and burned. The fine odor of burning grass and brush and the smell of ribbons of new ground being turned to face the sun were a delight and a promise to us farmers. After the brush was burned the land was ready for the plow.

Our little farm was a part of this country which turned out to be the last frontier of the dry land cotton farmer.

Thousands of acres of dry land cotton farms have since been turned back to grass, and other thousands of acres are growing grain crops, and most of the farming is done with machinery. Cotton raised by irrigation in Arizona, California, and Texas has replaced the acreage given over from the dry land method. Irrigated cotton in the Lower Rio Grande Valley of Texas, and cotton grown by the same method on the Great Plains of Texas, supplies much of the world's need for cotton of today.

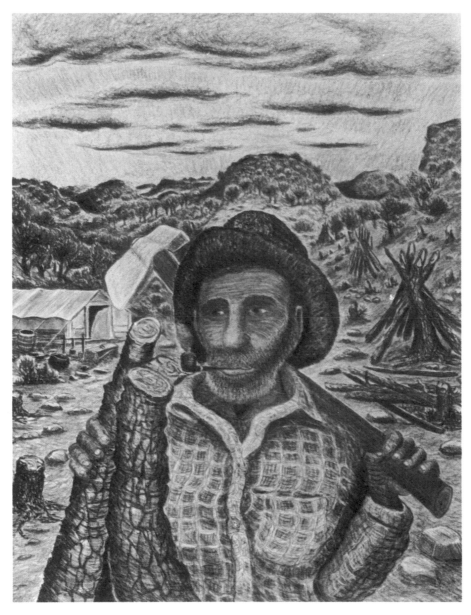

Post Cutter

11

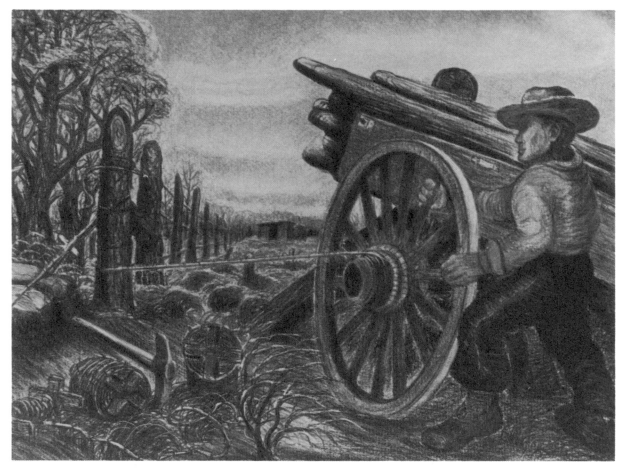

Resourceful

3
Homes

It was no small task to build houses in the new country, for lumber could only be obtained at railroad towns.

The mode of hauling lumber was by removing the wagon bed and placing the boards edgewise, side by side on the running gear of the wagon, in between the standards on the rocking gears. Bundles of shingles and kegs of nails and other small items rode on top of the boards. Often the pole to the running gear had to be lengthened to accommodate long boards. With so much condensed weight some loads required four horses or mules to pull the load.

Many settlers, ranchers in particular, used native stone to build houses and outbuildings.

Captain Bolin, like many sheep raisers, used rock to build pens for his sheep, and like most sheepmen, used a dependable Mexican to herd his sheep.

Lumber was expensive and barbed wire (we called it "bobwire") would cut animals severely when they ran into it. So, in order to overcome the cost of lumber and the danger of ruining livestock by their being cut up, picket corrals were built in which to pen range animals. Picket corrals were made by cutting tree limbs and small trees into various lengths and securing them in an upright position to form the pen.

The Alexander, Arledge, Ballard, Boatright, Cochran, David, Everett, Farrar, Frost, Hargrave, Odaom, and Russell ranches lay in the hills on the west side of the valley.

In the hills to the east were the Bolin, Jordan, Lampkin and Parker ranches where I hunted and trapped animals, and searched for arrowheads.

Once I saw the realization of a dream at the Parker ranch; Peyton Parker had by accident roped a half grown antelope.

Nugent's Homestead is an illustration of his homestead which I saw sometime after we arrived in Nolan County, for by that time all land eligible for homesteading was about gone. By 1898 over four million acres of land had been homesteaded in Texas.

Southern Memories wasn't located in the new country, but since it has been a well received lithograph and illustrates a type of house which housed many early day cotton farmers, I have included it in the homes of my diary.

I saw the double log cabin with its dog run (breezeway) as it sat on a barren, time worn clay hillside, in east Texas. I added the ash hopper, plantation bell, rail fence, cotton and sunflowers which were appropriate to the century old house with its stick and mud chimney and hand hewn shingles. The old Negro man standing in the doorway of the cabin is another symbol which I added to the old piece of architecture. His race played a great roll in the history of cotton.

In our new home we had a wood burning cook stove in the kitchen, and beside it a box in which to store wood and chips. A crock in which to churn milk, and a milk box in which vessels of milk rested in water, were covered with moistened cloths. A coffee mill was fastened onto a window sill where whole grain coffee was ground. We had what we called a "safe" in which our dishes were stored, and which had bins for meal, flour, sugar, cutlery, salt, and soda. Most anything used in the way of cooking, as well as food itself, was stored in the kitchen safe—and on a homemade wooden table.

Soap suds from the wash pot on wash days were used to scrub the kitchen floor. The suds were rinsed with clear water, which left a fine odor of pine and soap.

We were too poor to afford a parlor, so we used a bedroom for social purposes. In the room sat a wood burning heating stove and its wood-box beside it. Our best iron bedstead, with a feather mattress on it, was decorated with our fanciest counterpane. The Bible rested on book shelves; a striking clock rated its own shelf.

Father hung his sack of big bale smoking tobacco by the clock; the clock was his responsibility.

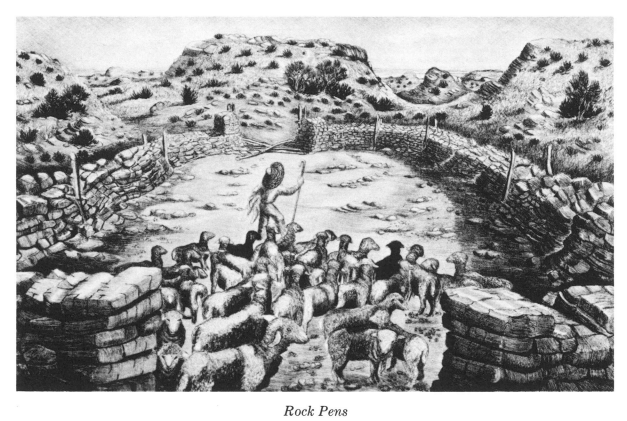

Rock Pens

Parker Ranch

Andrew Goodman

Our small barn housed milo maize heads, cottonseed for cow feed and for spring planting, a saddle, harness, and a meat box in which we salted our pork.

We had a small fenced enclosure called a stack–lot in which we stacked milo maize and cane that had been cut with a row–binder.

We didn't have housing for our buggy, wagon or farm tools, nor for our chickens—they roosted in trees.

When we bought our farm we were called one horse farmers, as our equipment consisted of a double shovel, a Georgia stock, a one horse planter, and a turning plow. All the equipment was pulled with one horse, with the exception of the turning plow, which required two horses.

Our farm was small, our house and barn were without paint, yet I doubt any dweller in a magnificent castle, amidst vast acres, ever experienced greater rest of heart and pleasure in his home than we did in ours.

Nugent's Homestead

Circuit Rider

4
Decker Schoolhouse

Church services were held at the Decker schoolhouse most of the year, and the schoolhouse provided a common meeting ground for various social gatherings, one of which was the occasion of community Christmas tree. One of those Christmas trees is deeply imprinted on the film of my memories.

December 24, 1902:

Time refused to move, but at last Christmas Eve arrived and I was to go to see my first community Christmas tree.

Upon reaching the schoolhouse I saw the storehouse of fairyland. From a giant cedar tree, reaching to the ceiling of the room, light shone from tallow candles fastened to its boughs. Flickering light from the candles revealed stockings filled with red apples and bright stick candy. Suspended on other branches of the tree, in among the stockings, were other packages wrapped in beautiful colors, and at the foot of the tree lay bundles of sugar cane stalks.

After a lot of friendly talk the schoolroom became deathly quiet and a big fat Santa Claus with a long white beard, dressed in bright red flannel, entered the dimly lit room. Santa Claus greeted us children and began removing packages from the tree, calling out the name on each package. Each time my name was called I had to go before the crowd and get my gift, which was terribly embarrassing. My presents consisted of a set of ABC blocks, a pair of mittens knitted by my mother, a stocking filled with candy and apples, and a bundle of sugar cane.

Jack Cochran had shipped some horses to southern Louisiana from his ranch and brought back a large quantity of sugar cane. He placed a bundle of the cane on the Christmas tree for every child in the neighborhood.

It makes my mouth hurt to think how sore it got from chewing the juice out of the cane stalks. I had to grease the corners of my mouth before I could get it open. My first Christmas tree was a time of excitement tempered with awe and mystery. No spectacle in later years ever equaled the grandeur of the occasion.

The custom of community Christmas trees at the schoolhouse soon passed away, and so did poundings for preachers.

Most of the money preachers received was from collections in which a hat was passed. With settlers having more goods than money, the preacher was rewarded with food, clothing, and household items. I was present at a pounding for Brother Bates, but I'm relying on family talk as to the goods he received.

Items brought to the schoolhouse and presented to Brother Bates were as follows: fancy jams and jellies, preserves, canned fruits, chow-chow, pickles and relishes, all of which were homemade, and with it some homemade sorghum syrup. Then some crochet, tatting, knit gloves and socks, and a friendship quilt. The friendship quilt consisted of blocks with the quilters' names chain stitched onto the blocks.

Quilting frames, cards for combing cotton and wool, a quilt scrap box for scraps of cloth to be saved, a button box which held sewing and knitting needles, thimbles, buttons and thread, and a conglomeration of other small items were found in most homes. Neighbor women met at the schoolhouse and in homes to hold quilting parties, where canning, gardening, births, ages, pregnancies, and other events were discussed.

At one quilting party talk got started about some young couples who had been dancing—that is waltzing. Square dancing was permitted, but a boy holding a girl in his arms while dancing was taboo to church members. The Baptists had a church trial and removed the names of the guilty from the church rolls.

My records show that all who committed the sin developed into responsible citizens.

Some fund raising projects were held at the schoolhouse. One was ice cream suppers for which women baked cakes and brought in ingredients with which to make ice cream. Proceeds from the sale went to support community projects.

The small fry worked their way at the suppers, so didn't have to pay for the cake and ice cream. We cranked the freezers and

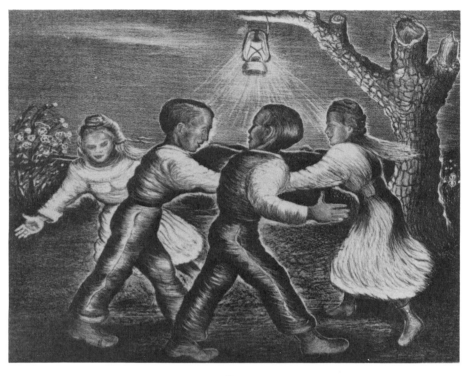

Snap

received a bonus in being allowed to spoon the ice cream from the paddle when it was removed from the freezer. Prior to this pleasure, we had the joy of licking the cake pan.

Other fund raising events were box suppers.

Wives, and hope–to–be–wives, prepared boxes of food which were auctioned off to the highest bidder, with the high bidder having the privilege of eating with the girl who prepared the food in the box. When a boy thought he recognized his girlfriend's box, that brought on high bidding, for someone in the crowd would keep the bid going as long as he dared, forcing the romantic gent to pay through the nose. I know from experience.

A party was held at the Chapman's on a Saturday night following the night of one box supper.

The party began with Edna Haggerton holding hands with John Sedberry. Mrs. Chapman asked me to snap someone. Just to show Ruth she had made a mistake about my liking Nettie, I snapped my fingers at her, and Nettie chased me around Edna and John until she caught me. Then Nettie snapped Silas Alexander, and the game went on and on, first one and then the other snapping. Not once did I snap Ruth or even look at her. Finally, what can be termed "the moment of truth" came. Ruth broke down and snapped me. I was almost trembling with joy when I got to hold her pretty little hands. The game of snap made it legal for boys and girls to hold hands.

After sifting the ashes of that romance, I discovered an inborn desire in man to want things hard to get, which, when obtained, often lose their appeal. I also learned that sometimes defeat is better than victory, for the last time I saw Ruth she was as big as a bale of cotton and they had ten snotty nose kids.

The Decker Literary Society met at the Decker Schoolhouse on the second Friday night of each month during school terms.

One meeting was devoted to public speaking. Two boys or men debated two others on subjects given out at the previous monthly meeting. Other speakers spoke on subjects of their own choosing on public speaking nights.

On the night of spelling matches (now called spelling bees) two leaders chose men, women, and youth from the audience and lined

their groups up on opposite sides of the schoolhouse. The leaders alternated in making their choices, with the first chosen always being those trained in the use of "The Blue Back Speller." When a person missed a word he had to sit down, which created a lot of tension as the lines grew shorter.

My father used the Blue Back Speller in teaching school, and many other settlers were taught from it. They pronounced the word syllable by syllable as they spelled it. In spelling such words as "Constantinople," "Mississippi" and other words with several syllables, they used a sort of auctioneer's chant.

Whatever the occasion at the Decker Schoolhouse, two men were always there, for they craved an audience. They had great effect upon my life so I'm projecting them into these sketches.

They are long departed, but if Clarence Phillips made it to heaven he is criticizing and mouthing about something. If Saint Peter should make any sort of change or effect progress of any sort, Clarence is against it and will say, "Heaven can't afford it."

On the other hand, if Billy Joe Clark is serving time with the booger man, and the devil will allow him to talk, he will be fairly well contented. The last time I heard about Billy Joe he was still blowing and going, but one thing about Billy Joe, he was a happy man, and Clarence wasn't, for sure.

Clarence wore a perpetual frown. His crescent shaped mouth with its corners turned down made him look like he had been eating green persimmons or had swallowed a sour pickle. Clarence had a bad case of dyspepsia, which some said made him contrary and bullheaded, while others said his attitude caused the dyspepsia. Some were of the opinion that he enjoyed his bellyache as much as Mrs. Ledbetter did talking about her "rheumatiz," head swimming, billiousness, liver complaint and various other ailments.

Clarence was opposed to anything that came up in the neighborhood, particularly if it required a change of any sort. He wasn't really in favor of anything except rain and a higher price for cotton. Dave Henry didn't cook sorghum syrup to suit him; it was foolishness when the Decker schoolhouse was painted. He complained about the actions of school trustees and county commissioners, taxes and Wall Street, oil companies, politicians and the government.

Billy Joe was the wit of the valley. He always had a joke or a tale which would top anyone's, and stood poised ready to grab the conversation, and very often broke right in and didn't wait his turn. There was a contemporary saying, "The first liar didn't have a chance around Billy Joe."

Once Billy Joe was to give a prepared speech at the Decker Literary Society. He was to deliver his speech on the subject of "woman's suffrage" after a debate between Albert and Asa Ross, on one team, debating Messers Hobbs and Ramsell on the subject of "which is the mightier, the pen or the sword."

It was election year and John Bond was running for re-election to the sheriff's office, and, being in the neighborhood, stayed for the meeting. Billy Joe had his heart set on getting on as deputy if Bond was elected, and wanted to snow the sheriff under when his time came to speak.

The stage was a platform in front of the blackboard, and curtains were strung on wires from one wall to the other in front of the stage. John and I had the curtain pulling job that night.

While the debate was going on Billy Joe would jump up every now and then and go outside to smoke a cigarette. He swaggered in and out of the house trying to hide his nervousness, but he was as nervous as a cat on a tin roof. After the debate ended and Billy Joe's time came, we drew the curtains back and stood behind them.

Minnie Fowler, the schoolteacher, introduced Billy Joe, and he came swaggering upon the stage as if he owned the place. He bowed and began his speech in a big booming voice, "Ladies and Gentlemen," then dropped his voice into a lower key, "I'm proud of this honor." Billy's voice seemed to frighten him. He had his speech memorized and began in a very scholarly manner, using words which he didn't ordinarily use.

His prepared speech didn't include a welcome to the visitors, but he wasn't about to overlook that opportunity, so he quit right in the middle of his speech and got ready to fix the sheriff good. "I'm honored to have the high sheriff of Nolan County with us," which was okay, but it got him off his track. He backed up to the beginning of his speech and stormed out, "I'm proud of this honor," and then turned the color of a bed of ashes, but raised his right arm in a big sweeping gesture, attempting a rally, and continued,

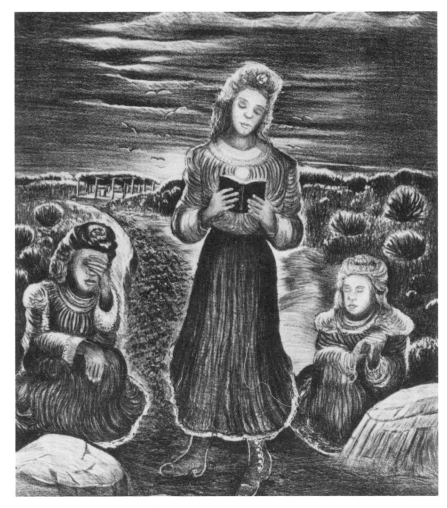

Grove Meeting for Women

"Ladies and Gentlemen," but got more confused than ever. Billy Joe's eyes became glazed, and he walked off the stage just like a wooden soldier or a mannequin. John and I pulled the curtains as he went out the back door to the schoolhouse.

Evidently Albert Ross benefited from public speaking experience at the Literary Society meetings, for he was elected to county treasurer and country judge seven terms, and elected to the office of district judge for thirty years.

I made a valedictory speech at one of the meetings and I was as numb as one's jaw is after a dentist has filled it with novocaine.

Later, I saw a few laymen pray in public who seemed to be delivering an oration directed to the crowd rather than to the Lord, and would get all wound up repeating themselves and make a mess of things. Such experiences, and that of Billy Joe, haunt me every time I get up before a crowd, and I'm just as frightened as I was when I made the first speech.

In my appearances I take some comfort in the fact that I have heard but few artists and writers who could speak in public worth a hoot. And, usually, I'm talking about stone lithography, a subject not well known to many people, and this also helps "Miltown" to quiet my nerves.

Now about Clarence—he was an "Aginer" of which the world today has a big population. Constructive criticism is good, but criticism without knowledge is harmful, as we are inclined to take criticism as fact. Clarence's attitude is reincarnated in millions of today's nit picking critics who have wise answers to most anything that comes up. Like shadows which hide from the sun, tolerance often flees from the wrath of intolerance. Seeing detestable traits in some men often teaches us more than in seeing virtue in others. Trying to avoid the faults of Clarence has been his influence on me.

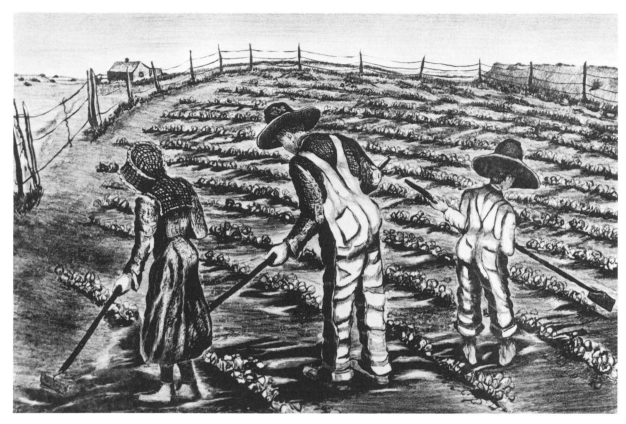

Chopping Time

5
School

After seven long childhood years, the time arrived when I had to curtail the pleasure of tricking doodlebugs out of their holes; holding onto a string attached to a junebug's leg and watch it fly in circles; watching fireflies flash lights in fruit jars after being caught; teasing a horned toad in hopes it would spit blood out of its eyes, and the dangerous sport of tantalizing tarantulas and vinegarroons.

It was about daybreak on the morning of October 1, 1904, when Jess and I hopped out of bed at the sound of mother grinding coffee. By the time she had breakfast ready we had milked the cows, fed the livestock, and were ready for our meal. After breakfast we started out on our two and one-half mile walk to the one room, one teacher, eight grade school at Decker. We went swinging down the lane, carrying our lunches in buckets which had been used for lard, our books inside homemade cloth book-satchels.

Extremely sensitive, timid, and filled with an inborn curiosity, I entered the world of three R's, "reading, riting, and rithmetic," and found the new world filled with conformity, routine, and red tape, and from that day until this I have been a rebel against all three.

I had little difficulty in learning my lessons, but the days were long and the routine was boring. I looked forward to lunch time and recess, at which time we played marbles, mumble-peg, leap frog, pop-the-whip, baseball, and other games, according to our ages. I also looked forward to the end of the six-month school term, despite the knowledge that I would have to chop cotton; however, spring and summer pleasure outweighed work.

All eight grades met in the one room schoolhouse. The room had a big pot bellied wood burning stove in the middle of the room. Near the stove, resting on a bench, was a water bucket and dipper which was used by all pupils. This was in the days before germs. The water bucket and dipper were also in common use in homes. Before I started smoking cigarette snipes and various other smoking material, once in a while I would get so much tobacco flavor off a dipper it would make my head swim.

The school grounds were equipped with two four-holers, one on each side of the grounds. Artisans sawed holes in the shapes of stars and half moon in the sides of the buildings. Sears Roebuck and Montgomery Ward catalogs filled the needs inside the structures. During class we held up our hands to be excused if we needed to use them.

Earlier, my father had taught school, but his health failed, and he and mother went to bed with the chickens and got up before the roosters started crowing in the morning. We had another assurance of being on time at school, for when mother began grinding coffee for breakfast, Jess and I arose and went into action. Like most settlers we used Arbuckle coffee. Signatures from the coffee brought many fine luxuries to the valley people, in particular to the small fry. I outgrew a genuine topaz ring which was secured with signatures from the coffee.

My first teacher was a tall, gangling raw-boned man, with a long coffee stained beard so thick he couldn't have smiled if he had wanted to. He wore the deportment of a four-star general and his rule was just as severe. He was even aloof to men in the neighborhood. We pupils were particular to address him as Professor Peck to his face, but to his back we dared the risk of calling him "Old Man Peck."

He believed in the theory that if the rod was spared, it would spoil the child, and he was well prepared to back up his belief, for in the corner of the school room next to the blackboard stood the finest collection of willow switches that could be found along Oak Creek. Professor Peck thought his fine collection of willow, if used in a manner similar to a public hanging, was more effective, so he stood the guilty one in view of the pupils to administer proper punishment. The word "sadist" was not yet in our vocabularies.

I was nervous, and not a brave boy, and the switches charmed me like a ground squirrel held in the hypnotic gaze of a rattlesnake. I didn't dread the sting of the willow as much as I did the

embarrassment of being whipped before my classmates, and the possibility of crying.

When the barefoot season of springtime arrived I began to dream, which made school work more boring. I dreamed about finding bird's nests with eggs in colors never seen before, of finding complete arrowheads, about water in the blue hole beginning to warm, and many other things which belonged to a boy's world. It was around May 1, 1905, when I was overpowered by my dreams.

It was intuition, or perhaps it was the stillness of the school room which shocked me back into the world of reality. It all happened just as depicted in my drawing *Old Man Peck*. In the death chamber, I glanced back and saw Professor Peck's corduroy trousers almost touching me; I became completely paralyzed.

After the wave of fear passed, I guess I had the same feeling as someone going to the gallows or guillotine. I had the relieved feeling in knowing something which I had dreaded for a long time was about to pass away. The executioner in slow measured tread began walking toward his favorite spot in the room, which prolonged the agony.

Most of the pupils pretended they were studying, but I could see many glancing at me, trying to hide their pleasure, and I saw the look on two or three boys' faces, the sort spectators had when watching gladiators fighting to the death in Rome. Jess had a look of sympathy overshadowed with disgust and I knew he was as helpless as Jack was when the giant was chasing him up the bean stalk. I realized I had to bear the burden alone.

While Professor Peck was walking, hesitatingly and slowly, toward his favorite spot, I took comfort in the words used by Brother Bates at a funeral when he said, "Bill Smith is in a world in which there are no burdens to bear." I wasn't exactly anxious to join Bill, but I did have that to look forward to. I also thought about dreams in which I was about to meet my Maker, and then would wake up with great joy to find I was still alive.

I guess I had Old Man Peck down wrong, for when he reached the corner of the room, to the disappointment of many pupils, he erased the problem on the blackboard and replaced it with another. I held up my hand to be excused, and when he nodded assent, I went flying to the four holer.

As Tuck, one of my friends would say, "It threw a scare into me," but the dream continued. Jess and I enrolled a little later in a correspondence course in Cartooning and Illustrating given by the Fine Arts Institute of Omaha, Nebraska. The lessons were three dollars each. Our three dollars soon played out, but not before we got some fundamentals in drawing, composition, and design.

September, 1912. I can't remember how we managed, but I'm sure at great sacrifice to my family; they spared me from the cotton patch to go to high school at Blackwell. One thing which helped was that I stayed with my sister, Gertrude, whose husband, Charlie Leach, was the town banker.

In school I had the distinction of sharing the hominy in my lunch box with Jack Frost, who later became a famous geologist and oil millionaire.

I was younger than most in my classes at Blackwell, and a lot more timid than any, but despite the tender age I made a brand new discovery—the creatures called girls.

Soon after I made the discovery, neighbors discovered a new creature in me, which Alec Pruitt pretty well described. I was holding hands with Ruth at a snap party and I guess I had quite a bit of fire in my eyes; anyway, I heard Alec in a loud whisper to Jess, "I think your little brother's comb is getting red." For those without chicken knowledge, his remark was about young roosters who were trying to get their crowing voices and begin chasing hens.

Maybe it was this beginning of romantic feeling or perhaps the influence of reading the writing of James Fennimore Cooper, Harold Bell Wright, Zane Grey, and others which helped me win a prize in literature. The Blackwell weekly newspaper offered a prize for a story, which was published.

December 5, 1912—My story, titled "Heroine of 2 Bar A Ranch," was the winner. I have the yellowed clipping well hidden from public view. I have never read any of my books after they were published. I think I could do so without embarrassment, but the Blackwell story is a horse of another color . . . Matt Dillon, U.S. Marshall, couldn't hold a light to the fast gun of my sweet but deadly heroine.

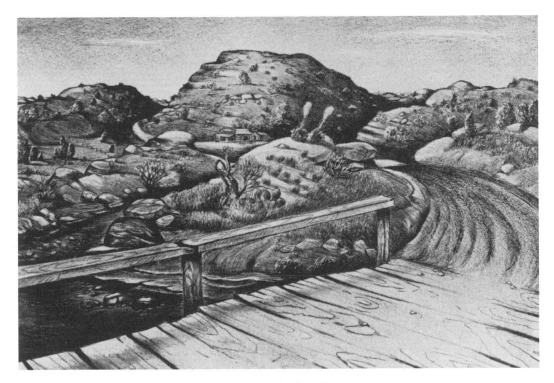

Road to Blackwell

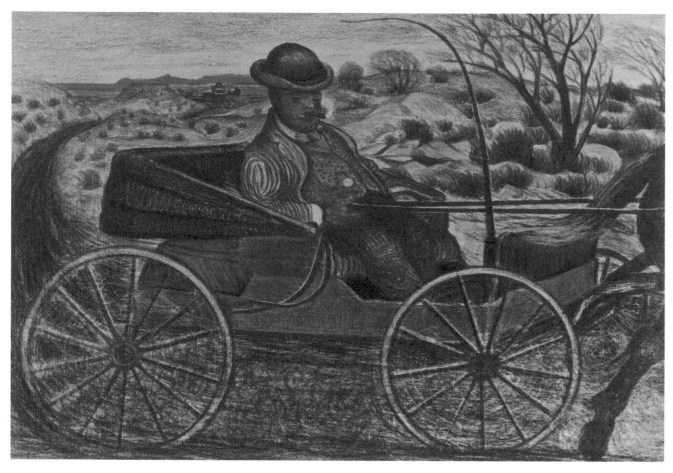

The Drummer

6
Circus—October 10, 1909

During the fall Hackenbeck-Wallace, a horse-drawn circus, came to Blackwell.

After the large exciting posters were pasted on the sides of barns in the country and on the sides of buildings in Blackwell, Jess and I began counting days until circus time. By the time the circus wagons passed our house we were so keyed up we were about ready for a stroke or heart attack.

The day was extremely hot for late October. At noon, old man Pearson, on his daily visit to his mail box, came on over the road to our house for his daily bull session. After getting himself comfortably seated he gave his chewing tobacco a fast workout and began the conversation, "Boys, hits a weather breeder," and using his blue polka dot bandana handkerchief to wipe sweat from his forehead, went on, "Hits jest too hot to stay this way."

In an absent-minded way we agreed, but in reality his words went in one ear and out the other; however, his prediction was well remembered before the day was over.

Since the moon would be full, we didn't have to fool around with a horse and buggy, so we pedaled the seven miles to Blackwell and parked our bicycles beside a tin warehouse back of Tom Carlisle's General Merchandise Store and entered the store from the rear. In the back end of the store Tom had a big shipping box for a table, knives, forks, spoons, bowls, cups and saucers, and a big bellied heating stove and coffee pot. Drummers and settlers bought food from the store shelves and used the space for dining. Surrounding the eating space was a hoop of cheese, a barrel of crackers, canned fruit, canned salmon and sardines, Duke's Mixture and Bull Durham smoking tobacco, Brown Mule, Star Navy, Peachy Plug, Thin and Thick Plug, Tinsley Chewing Tobacco, Garrett Snuff and cigars; also, a guillotine for cutting chewing tobacco. To make the place more attractive the space contained a showcase full of candy.

Since we brought onions and other food with us, and were timid anyway, we bought some groceries and ate in the tin warehouse.

We bought a can of sardines, king size, one dozen bananas, a large wedge of cheese, some crackers, and as much candy as our budget would allow, selecting horehound, the cheapest kind.

The warehouse had been closed all day, so it was so hot it was about ready to explode. It fairly shook and danced with heat, and while eating we paused long enough to look outside to see if we had been caught in a hail storm. We ate hurriedly in order to get to the circus. In doing so we worked ourselves into a lather of sweat. By the time we had slugged our food down and divided the candy by counting the sticks, we were sopping wet.

When we reached the circus grounds a man was up on a platform surrounded by a semicircle of people. He was real excited, gesturing and yelling, but at times spoke so low we couldn't hear him. We worked our way into the mob in order to hear and see better, but the only way we could see was up, and we couldn't hear much better.

The best we could tell, the circus man was yelling about a wild man from Borneo who was in the tent back of him. Since we couldn't see what was going on we had about decided to work our way out to the edge of the mob when an old grizzled rancher helped us make up our minds when he growled, "God a mighty," sniffed and said, "Who in the hell has been gutting fish?"

We rooted our way through shoes, boots, and legs to the outside of the crowd and got on its leeward side. We were expert on odors, but there was not much we could do about our condition at that time and, furthermore, we didn't smell bad to each other.

We knew older boys and men chewed Sen Sen for odors. And when we skinned a badger, 'possum or skunk, we smoked our hands and clothing over burning cedar brush. We found also that, after milking a cow, odors disappeared. After using our various remedies it is entirely possible that we didn't smell like a rose, but we had never had any complaints before.

Despite our odor and self-consciousness we saw the circus and

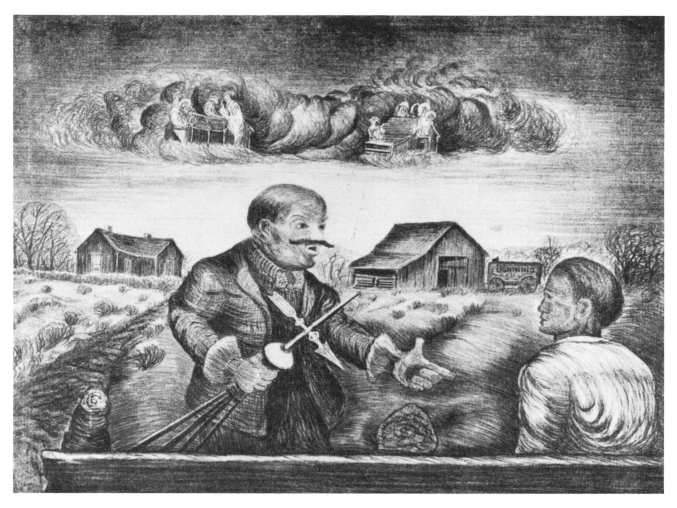

Lightning Rod Agent

as many side shows as our cotton picking money allowed, and had a whale of a time, but wound up broke.

When we walked out of the circus tent we thought about what old man Pearson had said, for a cold blast of wind almost swept us off our feet. The first "norther" was driving a cold wind down Oak Creek Valley. Clouds were rolling with the wind, and the moon, which we had depended on to ride by, couldn't give us a speck of light. So, we began walking beside our bicycles, pushing them squarely into the wind on our seven mile journey. By the time we had pushed our bikes along the rutted road it was almost time for our parents to get up for breakfast. However, we did have time for a short nap.

Dog tired and at peace with the world I entered a magic world in which money had no place and in which I wasn't the least bit timid. I ate a whole stalk of bananas, two cans of sardines and Tom told me to help myself to the candy. It was hard to make a choice so I ate all I wanted of the many kinds. Dressed in a brand new suit with new shoes and starched shirt I entered the circus tent chewing Sen Sen. In the tent I saw a whiskered goat, which I had always wanted, prompting dogs and ponies as they sailed through the air performing miracles.

Then the ethereal world which held no bad odors was torn apart by the shattering bellow of the Wild Man from Borneo; his screeching bellow faded into the cracking noise of mother grinding coffee.

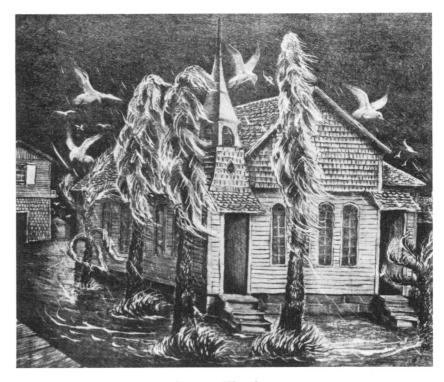

Stormy Weather

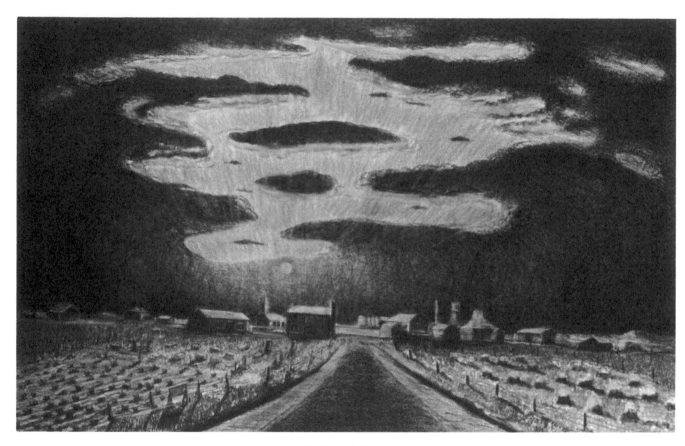

Railroad Town

7
The Square Dance—August 4, 1911

In our young days, John, my nephew, and I played some practical jokes, but nothing to compare with a low–down one which we did at a square dance at Virgil and Allie George's. Through a sense of shame, and also fear of being sued by survivors of the victims, their real names are withheld.

John's dad didn't overdo it, but he drank quite a bit of whiskey. He always brought back a good supply every time he went to Ballinger or Sweetwater. John and I had a habit of drawing off a little dab from each bottle and refilling the space with water. No whiskey drinking man liked watered whiskey, so we had to be very careful with our system, and very sparing with our supply.

One night, as was the custom of some grownups, we took our bottle to the square dance and hid it back of Virgil's barn, in what we considered a safe hiding place. Two boys in the neighborhood had the reputation of finding hidden whiskey and, also, were known as boys who enjoyed a little fist fight after they were liquored up. Red was a big red headed, long armed, loose jointed boy with a mean swing. Sam was small and wiry, and fast as double greased lightning.

It was summertime and hot as blue blazes. Virgil had all the windows up and doors open, allowing a little south breeze to air–condition the dancers. Preston Dunn was fiddling, Roy Prim was playing a guitar; Bill Pierce was calling; a special event was coming up later in the night. According to custom the dance was to last all night; coffee was available anytime, a snack was served about midnight, breakfast the next morning. Also, according to common practice, in order to help Allie out, neighbors had brought in eggs, side meat, cakes, pies. Anderson Shafer brought a cured ham.

Due to our age, John and I expected to return home about midnight.

When we came to the house from hiding our bottle, John Alexander was passing the hat to pay some of the musicians. After the collection Bill yelled, "Choose your pardners for a square." Preston and Roy began playing "Turkey in the Straw" and Bill

began calling the "Chicken Reel." Dancers began swinging their pardners and "do si do'ing" to beat the band.

Peeping through a window, watching the dance, John and I were swept up into the rip–snorting, foot–stomping, frenzy of the hoe–down and were "cutting the pigeon wing." Bill in his nasal twang was singing, "Chicken in the bread tray pecking out dough," when Red and Sam walked up to the window where we were standing. My legs turned to rubber . . . we panicked.

Knowing their reputation, we eased out of the crowd and sort of zig–zagged our course to the barn, and sure enough, we saw Sam and Red watching us in their casual deceptive way. We found our bottle and downed some real big swigs, for we wanted to at least get our share of the scarce product.

We knew we couldn't afford to tangle with Sam and Red, so I guess it was the whiskey which made us do what we did. Suddenly our kidneys wanted to move and we each donated a little to the almost empty bottle. We hid the bottle in a little easier place to find and went back to the dance.

Right away we saw the boys sauntering off in a different direction from the barn, but after going a short way they drove into the shadow of the barn. Poke Harris, who was the aristocrat of fiddle players, was going to provide the special event. Poke had a little over three thousand acres of ranch at the head of Oak Creek, at the foot of the divide. Among his possessions he claimed to have the finest fiddle in Texas. Historians might dispute this, but Nolan County people didn't. To uphold the dignity of his accomplishments with the violin, and I guess because he felt sorry for fiddlers with poor fiddles, he wouldn't take a penny for his services.

Poke looked the part of a musician. He had the long flowing beard of a patriarch, white and silky, and a head of hair which reached almost to his shoulders. He didn't look like other ranchers; he was plump, with unwrinkled skin and rosy cheeks, but his pink cheeks were not due to whiskey drinking.

Poke had his fingers quivering up and down the strings of his fiddle, playing his favorite mockingbird tune, and had the bird singing, when all of a sudden the hushed spell of the listeners was broken when Red and Sam came staggering in from the barn, yelling and laughing as loud as they could. I guess curiosity got the best of me and John or we would have hightailed it for home, for when Red laughed that meant fist fighting.

Once in a while boys from the divide or rabbit twisters from Coke County would come to some of the square dances and raise a little cain. Sam and Red were a self–appointed committee who seemed to enjoy taming the boys a little bit.

Please note: a rabbit twister was a person who, being short on food, would twist one of the little boogers out of a log or hole, cook and eat it. Since rabbits were not considered kosher food by a lot of people in the new country, it was considered a food to be used only when in extreme need. Coke County people referred to less fortunate people in other countries in a similar manner.

Back to the square dance . . . Virgil and some others tried to quiet Sam and Red, but they wouldn't listen, and the first thing you knew things got into a real mess. Sam and Red started laughing and yelling . . . Virgil's chickens began cackling and squawking, his dogs started barking, which I guess was the cause of one of Virgil's cows (with a bell on her) breaking out of the cow lot. Anyway, a dog was swinging from the cow's tail as she came bellowing towards the house. She would have gone inside if Allie hadn't seen her in time and slammed a door in her face. People were running around like chickens with their heads cut off, yelling, some doing a little bit of cussing while some were still trying to get Red and Sam quiet. Rufe McClure's horse got scared, broke loose and ran away with his buggy, and before things simmered down, torn shirts and bloody noses were everywhere.

When the noise was going on, I'm not sure but what coyotes joined their wailing voices to the bedlam of sounds. Anyway, Cas Russell, who lived over the mountain, said that his jack began braying and woke him up, so he heard the commotion just as plain as day.

John and I felt pretty badly about the situation, but we couldn't figure out if we left more whiskey in the bottle than we thought, or if it was the secondhand whiskey that made Sam and Red so mean.

8
Blue Hole

Fortunately, memory often retains the pleasant and discards the unpleasant. Great pleasure has come to many boys in exploring a river, a creek, or even a pond of water. From association with the waters and its environment it becomes so much a part of the boy that its memory never dims. I had such an experience.

Fed by cold crystal clear spring waters at its head, unfettered by civilization, the waters of Oak Creek, free from the silt of eroded farm land, rippled in tinkling notes over pebbly shoals, frolicked in boisterous gayety around boulders, and tumbled over limestone ledges until the stream made an abrupt turn one mile east of Decker. In making the turn, nature, with timeless patience, used occasional angry waters to carve a basin in which to collect a great pool of water . . . this was "Blue Hole."

In nature's sculpturing a high bank was left from which we could dive into the deepest water. The water tapered in depth from the bank on down stream far enough to allow us to swim for quite a distance. Waters feeding the pool created white foam as it plunged over a limestone shelf into the great basin of blue water.

At the lower part of the pool sun perch staked their claims in spring time, and cleansed circular spots of pebbles over which to spawn. Nearby, along the water's edge, watercress grew, furnishing nippy bites to further sharpen the ferocious appetites of the growing animals called boys.

On summer days, near the inaccessible west bank of the pool, turtles of all sizes dozed in the sun. Upon our approach crusted shells of the big ancient ones rattled as they slid into the cool depth of the water. The older ones were followed by the smaller, who paddled furiously in great fright. After being submerged for some time, periscopes of the larger turtles would appear along the water's edge, testing our intentions. Wherever scum or drift occurred upon the water's surface, snake doctors plied their trade. At an early age I fully believed that the insect really doctored snakes.

Nature's hand fashioned Blue Hole into a boy's world. Before Blue Hole was created Nature molded an upland from east to west across Nolan County. The upland divides run-off waters, with streams on its north side flowing into the Brazos River. Oak Creek, heading south from the divide, gathers waters from Bear Creek, Cottonwood Creek, Plum Creek, Pecan Creek, and other small streams on its way to the Colorado River.

Oak Creek, formed by Nature, was wondrously inhabited with nature's creatures. During winter we slipped up behind its high bank and shot wild duck. At other times we used grasshoppers, frogs, redworms, grub-worms, minnows, and, at times, fat meat to bait fish in the placid waters of Blue Hole. However, it was off bounds to fishing during warm days, its waters in turmoil from swimmers.

We could never wait for warm weather, and often plunged into its icy water during Indian Summer days in winter. Neighborhood boys meeting at Blue Hole on Saturday afternoons from early spring until the first norther arrived in the fall were as much a part of living as eating and breathing.

Blue Hole served several purposes. Swimming in nature's clutches saved us boys from the ordeal of bathing in a number three wash tub. Swimming built our muscles up to the point where most any boy could jump up, grab a limb, swing his body back and forth between his arms in a tumbling motion, which we called "skinning a cat." Or we could hold onto a limb with both hands, raise up and chin ourselves fifteen or twenty times. The number of times we chinned ourselves could be disputed, for time takes it toll, if you know what I mean.

From time to time, uninhibited, naked as jay birds, we would stand around on the banks of Blue Hole and compare muscles. I watched with admiration, and with a certain amount of envy, while big boys showed bicep muscles as large as a big lemon and even larger. I hardly ever demonstrated my muscles unless I was greatly

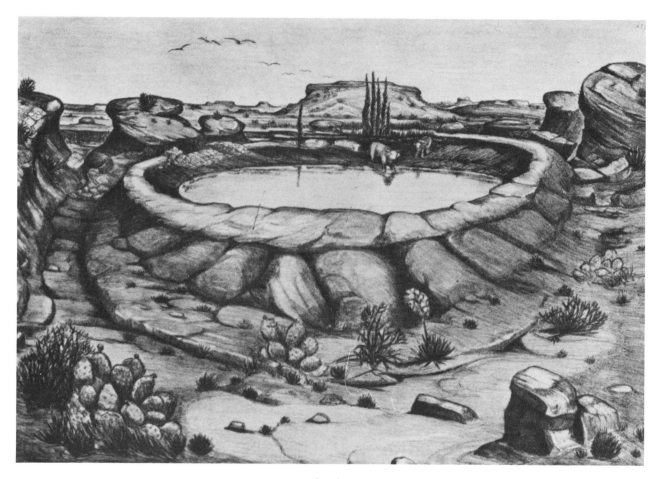

Oasis

urged to do so, for I could never get the bicep muscle on either arm to swell up larger than a walnut. But I had hopes of developing them into the size of those of our blacksmith, Mister Moore.

Mister Moore allowed me to crank his forge a time or two. Smelling the fine odor of coal burning in the furnace to his shop, watching him remove red hot plowshares from the fire, listening to the musical ring from the anvil as he pounded the red hot metal, made me want to be a blacksmith. His bravery in holding a horse's leg between his own while nailing shoes on was inspiring, but the most inspiring thing was in seeing his enormous muscles ripple up and down his forearm while he hammered the metal on his anvil. His huge muscles made me accept the advice of my older brothers, who told me that turning the grindstone while they sharpened axes and other tools would develop my muscles.

Blue Hole provided more than physical culture and hygiene to the select group who used its inhabitants for medical purposes.

Some boys in the neighborhood carried rabbits' feet and buckeyes for luck, and wore asafetida tied on a string around their necks to kill germs. We heard that scientists had found things called germs, so our group, being of scientific mind, developed a germ killer. We swallowed live minnows and allowed them to eat the germs. This also allowed us to display our bravery by seeing who would swallow the largest fish. We soon discovered that it was best to allow the fish to go down head first.

The theory must have worked, for our group had fewer cavities, less runny noses, fewer sore eyes than another group which was less scientific.

Blue Hole died in 1918, and the destiny of Oak Creek also changed at the same time. Drouth contributed to its demise and to the destiny of the waters of Oak Creek, but its death and the fate of its waters were due in greater part to an ever changing world. Most of the waters of Oak Creek and its tributaries are impounded now in a large beautiful lake situated near the border of Nolan and Coke Counties.

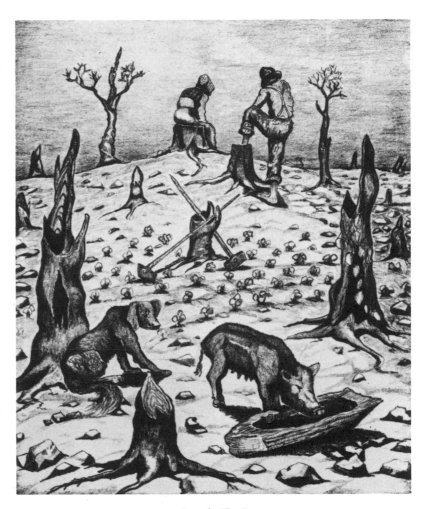

Row's End

37

Our Dreams

9
Marriage—July 8, 1916

It was during the summer of 1916 that I took an important step in life. I was only eighteen years old, with about as much sense as a blind goose, but I had a lot of dreams and a tremendous amount of surplus energy to offset the deficiency in intellect.

During that time, families were paternalistic; the father was head of the household, so it was only natural, but extremely embarrassing, when I summed up enough courage to make the announcement to my father that I was going to get married. I guess from my previous behavior, erratic moods of jealousy, hateful and silly actions, he was prepared for the shock, for he looked at me with a puzzled expression and gave me his blessing.

I think it was a relief to him, for with my disposition it is possible that if the marriage had been called off I might have later been married to some other girl by what we called the shotgun method.

I was always an admirer of the female sex, and having found what I considered the finest specimen in the world, I wasn't about to let her get away.

As my wedding day approached, July 8, 1916, I became so excited and impatient my actions were more or less like those of a robot. The night before the wedding we didn't have much twilight. A big yellow moon came creeping up behind the mountain in front of our house just as the fireball went down behind the hills across the valley. The moon had reached its full. While the moon rose slowly up into the heavens my mind was filled with racing thoughts. I wondered at the infinitesimal chance of being born. Or, was it chance? And how fragile the thread of life is!

My thoughts spun back through time to the cathedral and village in France which bear my father's name, and to the British Isles from whence came my mother's people. I thought about chains of marriages coming from the two places until they met in a new world, and to which my father and mother added their link. I wondered at the beginning and the end of the chains, and as to what my link would add. I dreamed, as I have all through life, of some day seeing the cathedral and village in France, going to Scotland.

I thought about the future of Maggie and me, of having our own family, of owning our own farm, and even dreamed of becoming rich, and flashes of the dream which the old phrenologist implanted in my mind bothered me. Yet unknown, misfortune would soon force me to take the first step of his prediction.

It would be improper to reveal all my thoughts, but a tangible one was the anticipated pleasure of the morrow, at which time I would drive the Model T thirty-five miles to the "White Flat Settlement" and get my betrothed for our wedding. Turbulent thoughts caused "wall eye" and I couldn't close my eyes, much less sleep. During the night I heard the clock strike every hour, and while laying awake memorized the sequence of songs of a mockingbird singing in a moonlit thicket in front of our house.

Birds always seem to sing softer at twilight and by moonlight, but in his repertoire of songs as he spilled out the red bird's song his voice rose to a high ringing note as he flew upward a few feet, flipped over and alighted on his same limb. Upon alighting he began the twittering of scissortails, the chirp of field larks, and then mocked the bark of our pet squirrels and the yap of our pet coyote.

After mocking the sounds of our pets and the birds of his acquaintance he added a few trills of his own, and after short pauses kept the imitations going until the moon's radiance came from the western sky. He then hushed and left the night to me and my thoughts.

Next morning the silence of the night was broken by chickens quarreling on their roosts, the soft murmur of awakening wild birds and the occasional tinkle of a cow bell. I listened to these muted voices announcing the opening of a new day and was up and saw the day's curtain rise long before the rooster's trumpet notes made the final announcement.

Molten Skies

By lamplight, I bathed in a number three wash tub, slipped into flour sack underwear, pulled on a white starched shirt and Sunday pants, then put my Sunday shoes on–in that order. Then I slicked my hair down to a good shine and was ready for the breakfast which mother had ready.

I was the only one who showed much excitement at the breakfast table, for my parents had seen seven of their children married, and Jess was already getting a bachelor's attitude, but I was so nervous I scalded my tongue with hot coffee. You know how miserable that can make you, but I didn't give it a thought. While I ate the new day opened with the sun sending crimson shafts bursting through clouds in the morning sky, and soon a rainbow formed an arc of shimmering colors reaching all the way across Oak Creek Valley.

I have always gazed with wonder and admiration at the ephemeral beauty of a rainbow, but the mysterious beauty of the raindrops in the sky was lost, for I was reminded of a saying, "A rainbow in the morning was a sailor's warning." I didn't let the saying worry me too much for when I cranked the Model T it began purring like a kitten and I jumped in and began singing, "Redwing, My Beautiful, Redwing. . . ." I was splitting wide open with joy. While the Model T bounced and raced down the open road, making better than twenty miles an hour, I did some serious thinking.

I thought about how easy it had been for me to fall in love, for I could do so "at the drop of a hat," as the saying goes. When younger, I fell in love with one of my school teachers who was older than my mother, but I guess it was only puppy love, for I fell out of love the first time she almost whipped me. I also gave a lot of serious thought about why it wasn't legal to have four or five wives . . . women didn't bring in much revenue (if a man had that many working wives he could retire in splendor). So, I could see that angle wouldn't work. As the saying goes, "I was hot as a firecracker."

But at last the day arrived when I would be content with one wife—she was the real McCoy. I felt that even if I had a dozen wives, Maggie would always be number one. I passed through Sweetwater, ticking along ten or fifteen miles an hour, singing "In the Shade of the Old Apple Tree."

By the time I was almost to Eskota I was burning the breeze better than twenty miles an hour. Having whistled and sung all of the romantic ballads which I knew, I was singing "When the Roll Is Called Up Yonder." About that time I saw a shower of rain sweep across the road ahead of me. If you have never been to Eskota, the earth is red clay, and, you talk about slick, when it rains butter is an abrasive beside it.

I guess it had been thundering and lightening some, but I was too happy and excited to pay any attention to it. Anyway, the rain brought me out of the clouds and down to earth, and reminded me of the saying about "the rainbow in the morning." The rain made me think of a lot of things. One was about the way old man Pearson described weather as if it were a person of the neuter gender, "When hit wants to, hit ken rain es easy es you please; en when hit gits stubborn, nothing ken make hit rain." "Hit" wanted to rain that morning.

I also thought about how we counted raindrops in our country, they were so precious, and how ordinarily a shower made me happy as a lark—and about how long it would take Maggie and me to walk back to Sweetwater—fifteen miles away.

A lot of people will not allow themselves to be caught up in the clouds of happiness for fear of tumbling back to earth in despair . . . I lived the full scale by nature.

When I reached the rain slick red clay road I went to the lower end of the scale, for the auto decided to go back to Sweetwater whence it came. The road was as slick as owl grease, but I loose herded the flivver into loops and figure eights, and finally headed toward Abilene and made it through a pasture to a stream running full of muddy red water. It would have taken more than muddy water to stop me, so I waded into the water and let the Model T cool off a bit.

I was a little bit bedraggled when I made it to my bride-to-be's home where I found her all dolled up in white—a white dress reached almost to her shoe tops, a white hat sat on top of her long braided hair. Maggie was slim (past tense), tall, had a long neck and small mouth and eyes as blue as a Texas sky after the clouds had rolled away after a rain shower.

We made our departure hurriedly, for we knew that if the rain continued it would take four horses to get us back to the slick dirt road.

41

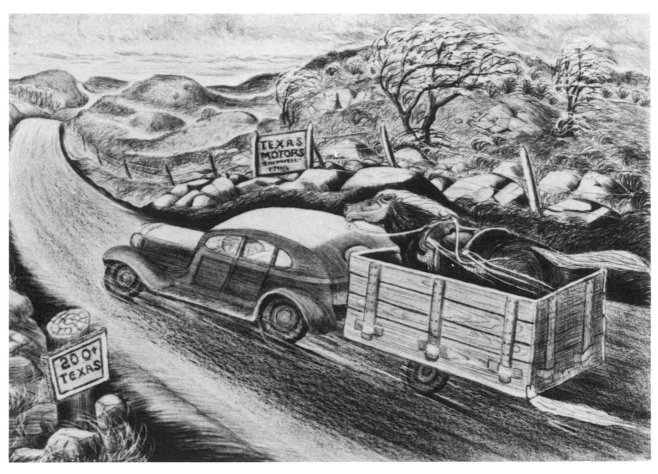

Texas Highway

When we reached the running stream it was even higher than it was when I had crossed it previously. I was accustomed to throwing a sixty pound sack of cotton across my shoulders, so Maggie's hundred pounds didn't phase me. I threw her over my shoulder and waded across, which saved her costume from red satin, but muddy water removed all the shine from my blue serge suit and left my peg top pants clinging to me like a glove—and fiery red. Most of my coat retained its blue color.

I wasn't of legal age to marry, so Albert, and Pearl, his wife, had the license and preacher ready when we reached their home in Sweetwater.

That night on our honeymoon we went to a snap party at Jess George's. It was Saturday night. Being married, we left the party a little early.

Monday morning we hit the cotton patch with two real sharp hoes. I gave Maggie one with a sharp edge, the best. Since it was our honeymoon, we didn't work the customary hours; it was seven o'clock before we went to work, and we took out around six in the afternoon.

To make hoeing a little more "pleasurable" (1966 word), our milo maize was about five feet tall, which provided a fine shade we could use any time we felt like it. In other words, it was a life of fun and ease until maize heading time came, followed by cotton picking a little bit later.

When it came to temptation I didn't have much backbone, for boys could butter me up and get me to do things when I was scared half to death. I guess I might have been a little more grownup at the time of my marriage—that is, a little bit.

After I got my wife properly installed, Alex Pruitt said to father, "By juckies, she looks like she could chop two acres of cotton in a day (which was from sun to sun) and can pick two hundred pounds of cotton in a day." Alec's appraisal was a quality looked for in brides at that time.

Jess, who turned out to be an old bachelor, lived at home with our parents, so we were now a family of five living in a four room house with a shed room. Right after our marriage mother warned Maggie, "He is the most stubborn and bullheaded of my nine children."

Now, fifty years later . . . she found out I was a moody, temperamental, sentimental person who never grew up. But she is a wise person, tolerant and understanding, a mother as well as a wife, and we have done a lot of joyful living. She has been the balance wheel which has kept the machinery of my life from flying apart.

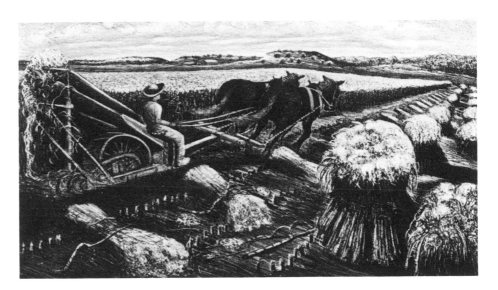

Milo Maize

43

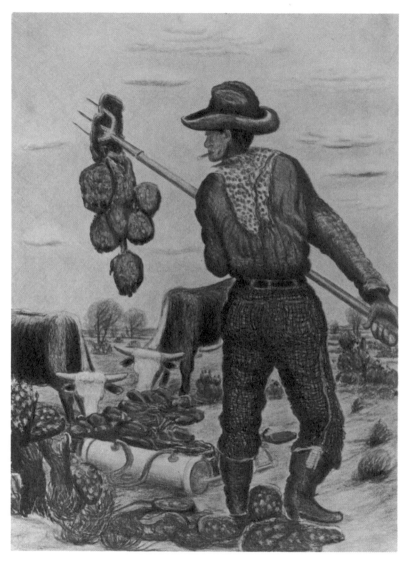

Bill Kitchens, 1917

44

10
Dry Years—1917-1918

Faith provides building blocks in life, but when shattered, the broken pieces are hard to mend.

During the dry years of 1917 and 1918 we had faith that rain would come, and through its beneficence, provide our needs.

Here are some thoughts and happenings during those years. . . .

September 10, 1917 . . . It looked as if we might make a bale of cotton. Jess stayed to gather it. Maggie and I, with a number of my kin, departed for the cotton fields in east Texas. We missed connection with an interurban at Fort Worth. Trailing from the Texas and Pacific depot to the interurban station with our suitcases, bundles, and various plunder, and without our tuxedos, we resembled the dispossessed of ancient times. A policeman with sympathy and a sense of humor said that if the conductor had seen us he would have waited. We caught the next interurban and got off at Covington, in Hill County, where Joe Lanier met us and moved us baggage and all to an abandoned farm house right in the middle of a snow white cotton patch. People in the neighborhood placed heavy locks on their henhouse doors.

The next few weeks Maggie and I sent our cotton picking money home to help feed our livestock. It was like pouring water down a rat hole.

October 20, 1917 . . . Cotton picking was about over. My kin departed for home. Maggie and I rode the interurban to McKinney, where Tom Giles met us at the station. Tom and Minnie Giles raised Maggie when she was orphaned.

November 17, 1917 . . . Tom, being a generous person, gave us a hundred dollars bonus and sent us back to west Texas.

November 19, 1917 . . . Jap Craig, who lives in the lower part of the valley, came over and invited Maggie and me down to scrap his cotton. He had been lucky and caught the best part of the dry weather showers, so had some cotton larger than bumblebee size.

The spotty showers gave him enough moisture to sow some oats, which were up. His milk cow grazed in the oat patch and delivered milk, which was churned into yellow butter. We had eaten so much peanut butter we were almost tongue tied, so you can imagine how good the butter tasted with the hot biscuits we had three times a day. Jap's wife set a good table, as it was called. We had sorghum syrup to go with the hot biscuits, and plenty of cakes and pies and other sweets. We had fried chicken morning, noon, and night. Yes, three times a day. It was a time to remember.

We didn't have any farm chores to perform, so all we had to do after scrapping cotton all day was to come in and wash up for a fine supper.

We made as high as four dollars a day. I hated to take Jap's money when we had finished. The luxuries of life almost turned my head. I thought about turning professional, picking cotton in the fall, chopping it in the spring, letting the other fellow worry about rain.

After we finished picking Jap's cotton I went to Fort Worth, where I stayed in a fourth class hotel near the packing houses, and worked for some time. It was European style, meals furnished and lunches to go. I slept in the bed at night, and Bill Harrington slept in it in daytime, which saved both of us money and didn't injure the pocket book of the hotel keeper.

I worked until time to get our farm land ready for another crop, then returned to the farm. Upon my return Jess and I pulled mesquite beans from trees to feed our horses, and burned stickers off pricky pear to feed our cattle the pears. Despite our efforts our cows got so poor they would not go as canners, and wouldn't even pay their freight to the packing houses in Fort Worth.

May 2, 1918 . . . This year seems to be a carbon copy of last year, but we are better prepared for whatever comes. Our crops of milo maize and cotton are breaking out of the ground. We had some good showers today. Our crops are planted in deep furrows which will give them protection. We will make the first plowing with the new farm implement born of necessity—the go-devil.

Erosion

May 3, 1918 . . . The morning star was still shining. A cool puff of wind came drifting in from the southwest and then lay quiet. The wet earth had a fine odor. Another stronger breeze swept across our fields, but it, too, died away. The streams of wind kept coming more often and in greater strength. By the time the sun came up the whispering winds had turned into a screaming, roaring, tearing monster, lashing at anything on top of the earth. A sandstorm was raging.

It was impossible to work in the field or even stay outdoors. Maggie began to sew, father and mother gathered reading material for the day, Jess and I sharpened our pencils and got ready to draw. We lighted three kerosene lamps and were battened down for the day. We drew the pup laying by the fire. We arranged dishes, pitchers and books in various arrangements and drew those. We drew buckets, shoes, anything which appealed to us.

A knothole in one eave of the house whistled as the wind poured through the hole. A wash tub lost its mooring and banged against the house. I anchored the tub and we resumed our drawing. From memory we drew our livestock and trees, and from imagination we drew fantastic objects. The drawings were fed to the fire.

During the day we could see tumble-weeds in a playful mood, rolling and tumbling with the wind. Once in a while the wind would slacken and they would roll up against barbwire fences and anchor themselves. Some would entwine themselves around fence posts and in mesquite tree tops. The wind in all its fury shredded the entangled weeds on the trees and buried the ones caught by wire fences.

The lashing winds scalped top soil from the earth and sent it skyward. Sand and gravel, being heavy, came back to earth whenever the wind paused in preparation for another attack. Dust, being lighter, traveled all the way to the Gulf of Mexico. At times dust turned day into artificial night. Darkness was so deep upon the face of the earth that we couldn't see across the road in front of our house. The storm raged all day. In late afternoon it began to go away, similar in movement to its coming. The sun lost its brilliance as it peeped through a halo of dust when it sank in the west. By midnight the wind had fallen asleep.

Maybe it was laziness but I enjoyed the wild elements.

4:30 p.m., August 4, 1918 . . . I was eager to see what the storm had done and upon viewing our crops I saw that planting in deep furrows had saved a few spots of cotton and milo maize stalks. There was nothing else to do but plant over. I didn't want to admit it, but things began to shape up like the year before. The sandstorm had not only raked the tiny stalks out of the ground, but in the process had removed a great amount of moisture from the earth.

Each year everyone continued to look for rain and found some sign that would predict rain. The age old sign of the position of the moon in the sky was twisted to predict rain. When the moon lay on its back or if it pointed toward the earth it was a wet moon. The number of stars found within the halo of the moon predicted the number of days before rain would come, but regardless of all signs, the rains stayed away.

In order to produce rain prayer meetings were held; when a snake was killed it was hung with its belly up to the sky.

When red ants worked in a frenzy, storing substances, or if a

46

terrapin was seen in its wobbly gait crawling as fast as it could, rains came, but not enough. Birds became scarce, which was due as much to a shortage of watering places as it was the lack of field grains and other food. The rippling waters of Oak Creek dried into pools, and the pools soon became beds of silt encasing dead fish and minnows. Somehow, insects survived. In early winter, crickets came in clouds to beat upon our window panes, and found shelter underneath the house to furnish us some pleasure in listening to their chirping on cold nights.

In the winter of 1918, Jess and I moved Carl Boatright and his family to the Spade Ranch where Carl burned stickers from prickly pears and fed the pears and cottonseed cake to the cattle. Jess and I stayed and trapped for about four weeks. We were on the Peter L, seven thousand acres, part of the Spade Ranch—a small part of the main ranch. A blizzard drove us home, but not before we had caught a large number of animals. We departed with our pelts and left the family sheltered from the north by the big dam, snug in their tent.

The dry years changed the pattern of commerce in the drouth stricken area, which covered considerable territory, and which gave birth to the famous dust bowl a few years later. Up until the time of the drouth, we, like most farmers, bought our groceries from Joe Davis and Tom Carlisle, and our hardware from Horn and Youngblood at Blackwell. We charged the merchandise all through the year, and paid for it when we gathered our crops during the fall. People in the upper valley traded on the same basis at Hargrave's General Merchandise Store at Maryneal. This was the typical way of trade in the vast area of the southwest. After the drouth, most farmers traded on a cash basis.

During these two years some settlers lost their farms, and a small number of ranchers went broke. A few merchants failed, but considering the enormity of the drouth, the numbers were small. However, it left its imprint on the lives of many.

Faith, though shattered, saved the country.

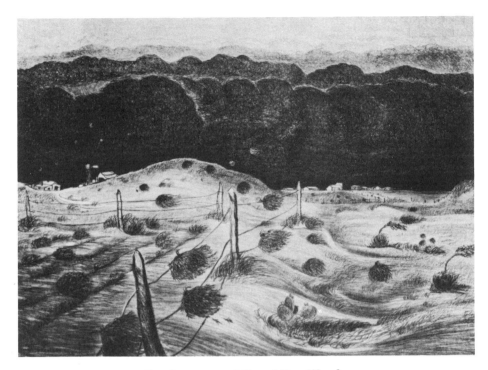

Sandstorm and Tumbling Weeds

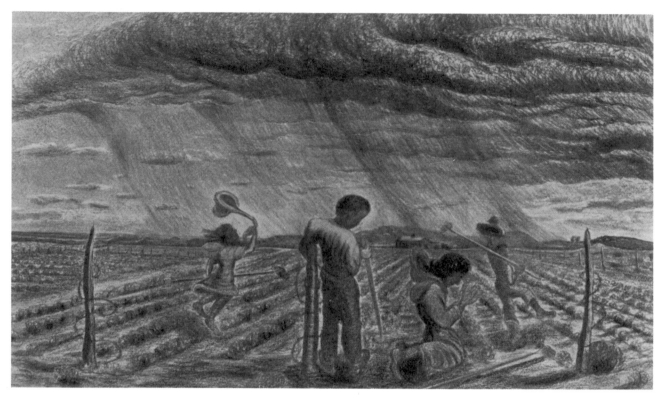

The Rains Came

11
1919

My notebook record shows 1919 was a great year for Maggie and me. We moved out on our own, made a fine crop, got an excellent price for it, and one of the greatest events of our lives took place.

The dry years had taken their toll, leaving fields stripped of topsoil and pasture land barren of grass; however, fields which had been damaged by winds were also benefitted by not having plant life withdraw substances from the soil. We called this "land laying out."

In the spring, rains came. Pecan Creek and other streams in the valley ran bank full; grass turned the pastures green once more. We had plenty of cotton blossoms on the Fourth of July, and cotton stalks reached to the cultivator seat when I made the last plowing, both of which were good crop signs.

Milo maize stalks waved big grain filled heads in gentle, moist breezes. However, the bountiful milo maize crop created some problems. We used pocket knives to cut the heads from the stalks. And no matter how mature the heads were, they had to be dried before being placed in the barn, otherwise they would heat and mold, and have even been known to create a fire.

When bringing in a wagon load of maize heads we pitched them on top of the barn for the sun to dry. Invariably showers would come up, and we would have to fork the maize heads into the barn. Then, when the showers were over, we had to reverse the operation and place them back on top of the barn. During this merry-go-round of work chaff from the maize heads would get inside our shirts and sting like the mischief.

The maize barn was a regular maternity ward for mice.

The first mouse that ran up my pant's leg shook me up, in particular, when he was trying to break out of his prison. I danced and shook my loose fitting coveralls, thinking I could shake him down, but he kept climbing. Finally, I got him hemmed up in the crotch of my pants and grabbed him, pants and all, and reduced the mice population by one mouse. The mouse incident didn't amount to anything compared to another experience which I had in the maize barn.

One day while stirring maize heads in the barn I almost lost my life, due to a prairie runner snake being in there with me. He didn't know it but I preferred mice to him, even if he wasn't poisonous. Some called the snake a coach-whip snake. They would slither and slip along the earth at terrific speed, which gave them the name. Most people said that a coach-whip snake was harmless, but any snake was and has always been harmful to me, even a dead one.

At that time in life I could pucker and whistle a little bit. I could not whistle any known tunes and was more or less a composer, I suppose, for I made my own tunes as I went along.

That particular morning I was whistling sad tunes. I think I started out with a sort of version resembling the tune of "Shall We Gather at the River" and had trailed off on my own when a doggone snake slid up inside one leg of my overalls. When I felt the cold belly of the snake against my naked leg I went crazy as a bat and ran out of the barn door, stumbling and falling, and fell against the side of the feed trough.

One can dream about a lot of things in a short time and the same is true of someone about to meet death, which I thought I was about to do. I guess it was only seconds from the time the snake entered my pants, but I died a thousand deaths before I saw him whipping along the earth, looking back at me as I lay beside the feed trough. He had shot out the loose fitting side of my overalls immediately after his unwelcome entry.

Although powerfully weak I made it to the house, and after a bath and fresh overalls I felt considerably better, but if I had been wearing pants with a belt you wouldn't be reading this diary.

When autumn arrived our little farm became nature's wonderland, a farmer's dream come true.

On early mornings we listened to woodland voices. First, the call of bobwhites near our barn, followed by the lonely chirping of field larks as they bobbed back and forth on fence posts surrounding

Boatright Ranch

our cotton patch. Mockingbirds had lost their exuberant summer mimicry, but the racuous cawing of ravens and the loud scolding voices of jays echoed up and down the woodland bottom.

The woodland music was inspiring; however, it caused a wave of sadness, for I knew it was the grand finale of summer, the curtain was going down, and soon the woods would be silent.

We could look down from our three room castle on the hill and see myriads of white open bolls which made our cotton patch look as if winter had spread a blanket of snow over the field. Our livestock were sleek and fat: in fact, our hogs were so fat they ate sitting down. We had an abundance of eggs, milk, and butter; our barn was bulging with milo maize heads, and ricks of bundle feed filled our stock-lot. It was a farmer's paradise. We dwelled in the land of milk and honey. The goose hung high.

Instead of our picking cotton for others, pickers camped in Pecan Creek bottoms and picked for us. Cotton brought forty cents per pound after being ginned. A five hundred pound bale brought two hundred dollars, and the seed paid for the ginning and money besides.

It was late spring when Maggie and I, with our new-born son moved to the Boatright Place. The three room square schoolhouse-type house sat on a hill overlooking the bottom land of Pecan Creek, which split the 160 acre farm almost in half. On top of the hill, south of the house, stood a windmill which creaked day and night, pumping water which our livestock drank, and which we used to irrigate our garden.

Nature was a little harsh in providing gyp-water, but endowed the country with an abundance of wind. All day and all night we could hear the windmill in its labor bringing cold water out of its earthly prison. The prison was formed of gypsum rock, which gave the water its obnoxious flavor, most especially when warm. Upon exposure to air the water had an odor similar to exploded gunpowder, and it contained some of the explosive properties of gunpowder upon contact with human bowels.

We always explained the violence of the water to those unfamiliar, and advised them to be sure of their control, to drink sparingly, to look for a place in which to hide. For people over thirty-five whose bowels had begun to slow down, it saved them from having to take a round of calomel—a common remedy of the time.

Each stroke of the sucker rod of the windmill brought water gushing out of a two inch pipe. The water ran down to a surface tank built on the side of the hill. The cascade of water kept the tank overflowing into another pipe, which reached to our vegetable garden. This engineering feat had its great reward.

In season we could gather a gallon of baseball size tomatoes most anytime, and other vegetables in proportion, but there was a fly in the ointment—we had to go armed, for rattlesnakes guarded the garden gate. Our survival on the Boatright place must have been due to forces above.

We had a backset right after moving to the place. It was due to a hangover from the dry years. During the dry years everyone said it would take a storm to break up the drought, and sure enough it did.

A few days before the storm, as was his custom, Caleb Pearson hobbled across the mountain to his mail box, which stood across the road from our house. As usual he looked into his empty box and came across the road swinging his cane and tapping the ground with it as he swung his stiff leg in unison with the cane. Also according to habit, after reaching our front porch he greeted us, "Howdy!" and then unloaded his cud of tobacco, used his pocket knife and cut off a fresh chew of Brown Mule. He poked the new chew into his toothless mouth through a hole in his porcupine beard, shifted it around to get it properly moistened and, with a look of pleasure, came on inside for his daily session.

With deliberate care he got his stiff leg properly situated, stood his cane by his chair and began the conversation, "Jest looks like we 'uns gona have some weather." He gave his tobacco a good gumming and continued, "Hit jest can't stay this way," and it didn't.

One night we thought little about a storm cloud, for we had seen such performances for the past two years. Lightning would flash, thunder shook the earth, rain would fall, just enough to dampen the top of the earth, and a dry norther would blow in and drive the clouds away. Along about midnight we were jarred out of bed by a noise about like ten sandstorms rolled into one. The roar of wind and constant claps of thunder were hard to tell apart.

51

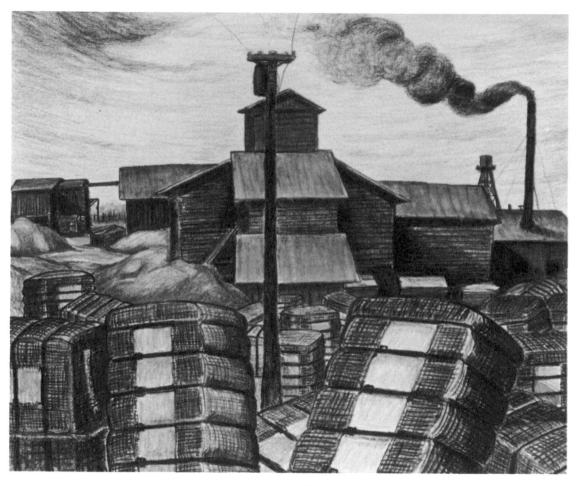

Cotton Gin

I longed for the quiet, serene atmosphere of our cellar. It was sort of bare at the time, but memory lingered of the fine smell of sweet potatoes banked in ashes on the cellar floor; of canned fruits and vegetables in glass jars on shelves in the stormhouse; even the fine smell of its earthern walls would have been heavenly at the time. The stormhouse was something special and enjoyable, but for some reason I could never understand, my father refused to go into the cellar.

These were only wishful thoughts which came in flashes as the storm roared and battered everything outside.

In panic I wrapped our newly born son in a blanket, waiting for a lull in the storm to make a dash for the cellar. I guess I would have made a mad dash for it if it had not been for the calm counsel of my father. Suddenly the cry of the wind dropped to a whisper and the stillness of the night was equally as frightening as a roaring madness had been. The quiet lasted only seconds. Then we heard hail striking the house. The noise of hail was a relief and soon it gave way to a steady downpour of rain, and we were transformed into a happy family.

Next morning all outdoors sparkled beneath a benign sun as it drew pleasant odors from the wet earth. Adding to pleasant sights and smells, long departed tree frogs appeared from some mysterious source and were croaking in rhythm around pools of water near the house. We could hear the voices of other frogs mingled in the muted, distant roar of Oak Creek's swollen waters.

Many believed that heavy rains rained fish and frogs. The theory had some backing, for, after heavy rains, fish were caught in unlikely places, and frogs appeared from somewhere.

With all outdoors washed clean and shining bright, an air of jubilation prevailed, for we sensed the drouth was broken and it was.

The storm did very little damage to my parents' house, but the roof of the barn was blown off and our two holer lay on its side about a hundred yards from its foundation. Two windmills were blown over in the neighborhood, and some other neighbors had about equal damage to ours.

Some time before the storm struck I had made a trade with Carl Boatright to farm his place on a third and fourth basis, with Carl getting one-fourth from the proceeds of the cotton and one-third of all grain raised, a common custom in sharecropping at that time.

We had moved part of our things to the Boatright place the day before the storm, and were going to move the rest the next day. The Boatright house was blown off its blocks and dragged along the ground a few feet, leaving it flat on the rocky ground, with the exception of a small opening underneath the southwest corner of the house. This crack was caused by a low place in the earth.

After getting completely moved, Maggie and I were happy as larks in our domicile. We had a folding bed in the front room, an iron bedstead installed in the second room, and the other room contained our oil burning cook-stove and kitchen equipment.

Our milo maize and cotton were up to a good stand when a sour note came into the picture. We started missing little chickens. A hen would hatch a setting of eggs and the little chicks would soon disappear. We would see an old hen wandering around, clucking to herself, without a chicken following her. We suspicioned snakes until one day, by accident, I caught the real killer.

Coming in from Pecan Creek bottoms with two squirrels in one hand and my twenty-two rifle in the other, I saw a big brindle house cat grab a little chicken. He saw me just as he grabbed the chick, and away he went toward the house.

Instantly I dropped the squirrels and took a shot at the cat without aiming, and with luck, or maybe bad luck, the bullet struck the cat as he ran in leaps and bounds toward the crack under the house. He scooted under the house still holding onto the chicken. I went into the house and watched for him to come out, but he failed to do so. I took some bread and tried to coax him out.

He growled, spat, and yowled far more than any wildcat that I had experienced with. I thought for a minute he was going to come out and attack me. I went into the house and got my shotgun, and went back out to see what his intentions were. Naturally I couldn't afford to shoot him under the house so I gave up after he failed to appear.

Next morning I peeped under the house. Getting no comment, I was satisfied that he had slipped away during the night. But in a few days, going out the north door, I got a whiff to advise me differently.

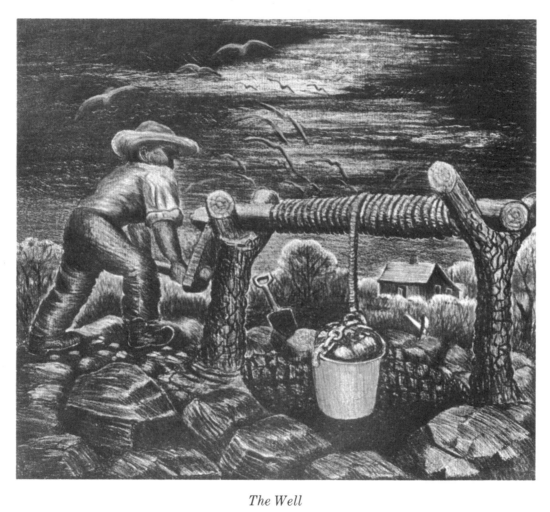

The Well

54

The dead cat presented a sizeable problem. The house was so low on the ground I couldn't fish him out and I was too busy in the field to fool around and prize the house up. Anyway, we didn't have to live with the odor for more than three or four weeks, which didn't amount to a hill of beans in a year like 1919.

Just before moving to the Boatright place the great event happened to Maggie and me. It was twilight on March third when Maggie began ailing and we called Doctor Richardson who lived on the divide. By the time he had driven the seven miles she was in real pain and I was getting frantic.

I was pacing the floor like a caged tiger, filled with emotions of fear, remorse, anxiety, anticipation, and with thoughts of hope and wonder about the miracle of birth.

I had to fight pessimistic thoughts, for birth at the time seemed impossible. I also felt the tremendous responsibility of procreation, in which the act brings life into this world, not of its own free will, and all life is destined to die. In my troubled mind I turned to the thought that man, the greatest of all creations, was surely destined to no less than the resurrection of all nature, and he, too, would live as long as the sun, moon, and stars continued in their appointed places. I knew that the cavalcade of human life had been moving on its endless journey down through the ages.

From these thoughts I drew some comfort, but I was held in the grip of anxiety, and the mystery remained.

On through the night Maggie would get a little ease from pain, my mother and the doctor would nap a little in their chairs, but I remained as wide awake as a hoot owl. Before the break of day I made a promise to myself that Maggie would never have to endure such agony again.

The morning of March 3, 1919, came with Maggie resting, so the family had breakfast with the doctor, and Jess went to work in the field. I always looked forward to a good breakfast, but I missed that one, for my appetite had departed.

Maggie and I had been wishing for a boy, with hope and prayer that he would be intelligent and without physical defects. Up to that time I didn't realize how thankful parents should be when such wishes were granted, nor did I appreciate my own mother before that time as much as I did afterwards. The sun was two hours high the next morning when the doctor made final preparation for delivery.

Maggie's suffering became almost unbearable, and I had to leave the room, but I did see the doctor passing cotton, saturated with chloroform, under her nose. I went back into the room in time to see our boy get his first spanking.

Suddenly a great surge of joy swept away all my troublesome emotions. With a heart filled with gratitude, and a small amount of pride, I went out into the field, hooked my thumbs underneath the suspenders of my overalls, reared back and said to Jess, "I'm papa."

A midwife stayed with Maggie for two weeks, and soon thereafter we moved to the Boatright Place.

Family

55

Autumn

56

12
Chicken Fever—1919-1920

When Jess and I caught chicken fever, little did we suspect the many complications the malady would bring.

During the time others had caught the fever and were ahead of us in the easy way to get rich. On paper it was a dead cinch to make a fortune out of chickens, and still grow cotton in the usual way. We thought we would gradually wean away from cotton and allow our chickens to work for us. We bought a book titled *The Standard of Perfection*, which contained illustrations of hens and roosters of various breeds, and described the fine points of each fowl. We subscribed to two poultry journals, all of which increased our temperature.

We pooled our cotton crop money of 1919 to use as capital and bought a miniature printing press and ran off letterheads and literature under the heading of "Lone Star Poultry Farms." We each bought some fancy breeding stock, and built pens and houses in which to keep them, and allowed our common fowls freedom of the range. Jess had his establishment at home and I had mine on the Boatright Place where I lived.

Right off the reel a million things began to happen in my part of the business, and Jess had problems also.

Showers of rain would come up and Maggie and I would try to get the little chickens under shelter. I guess chickens and turkeys must be the most ignorant of all animal life, for the little ones would go anywhere but where we wanted them to go. We would wind up gathering the drowned chickens and drying them out in the oven of our cook stove. We would place them in the oven, as limp and lifeless as could be, and soon a few would start kicking around, and we would take them outside and place another batch in the oven.

Upon taking the revived chickens outside, they would wobble around on limber legs just like they were on a tear, get their eyes open one at a time, and go about their business, seemingly ignorant of the fact that we had saved their lives. If a rain came up the next day, we would have to go through the same procedure.

Mites, blue-bugs, fleas, and chiggers began troubling the resurrected chickens. We dug pits and filled them with wood ashes for the chickens to wallow in, which helped the mite problem a little. We mixed lubricating oil drainings with kerosene and sprayed the roosts of the chicken houses and coops, which destroyed fleas and blue-bugs to a certain extent. Chiggers gathered in clusters under the wings and leg joints of the chickens and caused swelling so severe we lost some little ones to the chiggers despite the fact that we greased the infected places with salty meat grease, which destroyed some chiggers.

Then, two diseases took their toll of misery and death. Roup, a sort of pneumonia, clogged their nasal passages, causing the chickens to wheeze like a person with asthma. Sorehead caused the chicken's head to turn the color of tar and swell to where they couldn't see. At times our chicken farms were chicken hospitals; however, Jess seemed to have less problems.

Along with insects and diseases, snakes, possums, skunks, civet cats, wild house cats, wildcats, coyotes, hawks, owls, and maybe some other creatures were after our chickens.

Most everyone in the valley, that is young men, had some sort of fighting roosters, most of which were mixed breeds, mixtures of Leghorns, Wyandottes, Rhode Island Reds, Dominickers, and other breeds.

John Steven, in Hill County, had sent my nephew, John, a setting of eggs from his fighting game chickens, and John had two roosters which were whipping everything in the valley. Mr. Steven found out that I wanted a fighting game rooster, so he sent me a setting of eggs. We had an old hen who loved to set so much that when we tried to break her from setting by removing her nest, she would come back and hover over the naked ground where the nest had been. She had a lot of fever in her body, which made the little ones pop out of their shells on the twenty-first day, just like popcorn in a hot skillet.

For the next nineteen days it was almost impossible to catch the old hen away from her nest. She would come off her nest,

Black Snake Demonstration

gobble up a few milo maize grains, rapidly swallow a little water, and was back on the job. In her eagerness she began to show wear and tear. Her breast was almost bare of feathers, her tail feathers were sweated off, leaving a ragged back end resembling little chickens which had not feathered out, given a good blistering by the sun.

It would have taken more than blistering to have stopped the old dedicated hen. On the twentieth day I heard her cackling to beat the band, and I ran like a scalded duck to see what it was all about. When I reached her, she was walking up and down on the platform in front of her nest, winking at me with her back end, beating her wings against the boards and pecking at something inside the nest.

I peeped inside the nest and saw the granddaddy of all bullsnakes, with a knot in its belly as big as a water jug. The knot was caused by fifteen fighting game eggs ready to hatch. The old hen tried to help me kill the snake, and after we had killed the snake she came back and hovered over the empty nest.

Hens are as different as women in their ways. I had another hen who had so much life in her that she begrudged the time it took to hatch her eggs. As old man Pearson would say, she "hoped" me out of my sadness.

Just before Caleb departed for a newer country he was admiring the old hen and said, "Son, that old leghorn hen of yourn is a ring tailed tooter." He blew out a cud of tobacco, reloaded, and continued his remarks, "I shore would like to have a rooster from her." Bless his heart, old man Pearson didn't live to know what a reputation one of her sons developed.

Right from the beginning the little leghorn rooster had more spunk than any chicken was supposed to have. His nerve was in proportion to the obsession of the old setting hen. The little booger came by his qualities from inheritance and environment, the balance a question debated in human behavior.

Each year his mother would disappear into the woods and we wouldn't see her for three weeks. At the end of the third week she would come in from the woods, herding a gang of little stripped chickens. The accomplishment was almost a miracle, for the woods was full of skunks, possums, wild cats, snakes, and others who loved a chicken diet.

The little rooster was a pest from the time he was hatched until the day I matched him with a game rooster. He was an aggravation to his mother. He would stray away from the flock, and at other times take worms and bugs from his brothers and sisters after they had caught the food. When he did, his mother would knock him sky western crooked, but it didn't teach him a thing; he would do it again and again.

At roosting time, when all the other brood would be peeping out from under his mother, cheeping happily, he would be wandering around. Then, when he decided to go to bed, one of

Day's End

nature's most peaceful family scenes was disrupted by his clambering over the other chicks and getting on top of his mother. He would raise such a disturbance, causing the old hen to go through the hovering procedure again. The little ones would again collect underneath the hen, and here he would come and start climbing all over his brothers and sisters, and wind up snuggling underneath one wing of his mother with his head poked out.

The little rooster took on the responsibility of crowing before he was as big as your fist; his voice changed two or three times before he got his permanent crowing voice. After he got his regular voice he crowed with great authority from daybreak until roosting time at night. On rainy days some of my roosters, crowing with heavy voices, sounded lonesome as they echoed up and down Pecan Creek. The little rooster would answer each one with a clear, ringing, vigorous crow.

The little leghorn aggravated our dog, Ring, to no end. He would rout him out of his nap in some shady spot and send him away all humped up, hunting another place in which to finish his

Cornered

nap. He spent half his time at the barn bossing the other chickens, pestering our livestock, and the other half around the house, looking for something to get into.

At the barn, he would get up into the feed trough and grab grain right out from under our horses' mouths. At other times he would pick up fallen grain right from under the horses' hooves. All that saved him from their hooves was his being quick as lightning.

Nearly all of my roosters were twice as big as the little leghorn, but they were as afraid of him as if he were a bear. If one of the big roosters got on top of a hen, he would knock him winding, then rear back and crow. He got so domineering the big roosters didn't get much pleasure out of catching the hens; however, they did chase some on the sly.

When I got in his way he would flog my pants, and once or twice caught me stooped over and let me have it in the face.

His mother raised her brood in a half-wild state. One day as usual, the little outlaw chicken was wandering off from the rest of the others when a blue darter hawk spied him and came swooping in with its talons open, ready to grab. His mother gave a warning squawk and came to his rescue. The hawk's claws were within inches of the little chicken when the hen met the hawk with wild fury. Before it could reverse its dive she almost caught the hawk. She sailed across the draw right after the hawk, but it got away.

With fighting blood such as he had come by, I wanted to match him with a game rooster. So, I asked John to bring one over. The arrangement was made by telephone, and by the time John arrived, some eavesdroppers had dropped by. I'm sure I had exaggerated the fighting ability of my rooster. By the time we got the cocks together I felt my honor was a little bit involved.

We found the leghorn at the barn running things to suit himself. John released his rooster from its coop and it stood, with its comb trimmed, on big muscular legs spread apart, looking like a fighting cock. We didn't put steel gaffs on the game for I didn't want my rooster killed.

My rooster soon discovered the stranger. With head bobbing up and down in unison with his curious but confident walk, he strode up and confronted the game. The game sort of ignored the little leghorn; however, they exchanged some chicken talk. The little rooster picked up a stick and pitched it up in the air, which

seemed to have been some sort of dare, for when he did, the game, with swift movement of wings and feet, knocked the leghorn rolling. It surprised the little chicken, but he made a pass at the game and it knocked him for a loop again. This brought smiles and a little ribbing from the spectators.

I felt sorry for the little booger, for it was the first time that I had ever seen him the least bit humble, but he wasn't ready to give up, and attacked the game again. Instead, the game knocking him over, it got a hold of his comb with beak and spurs, and when the little rooster got loose he was a bloody mess.

The little rooster seemed to be sort of groggy when they met again, with their hackles raised, beaks almost touching, glaring at each other.

While the two cocks stood figuring out their next move, the leghorn's head was bleeding so much that he could hardly see, so we decided to call the game winner and stop the match. But before we could catch our roosters the leghorn came alive and tore into the game, flogging, pecking and spurring so fast the game couldn't tell where he was coming from. The game hid its head under its wing, trying to get away from the fury of the little chicken. That didn't work, so the gamecock began running, the little rooster riding on top of him.

We caught our roosters and gave them a good washing. John put his back in its coop and I turned the leghorn loose. When I did, he reared bck and crowed the bragginest crow that you have ever heard.

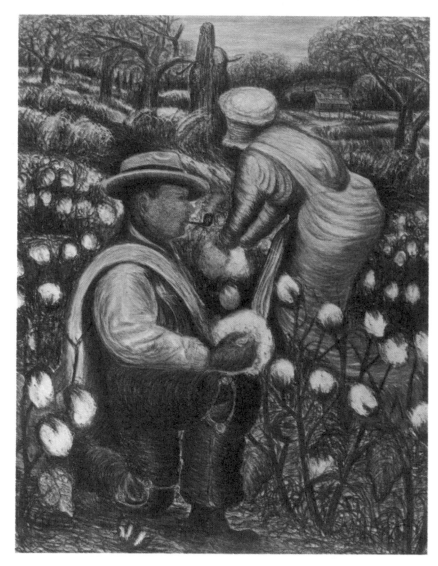

Buck and Annie

13
Farewell—1920

The year 1920 was one of beauty and growth on the Boatright Place.

The budding of willow and redbud in early spring started a pageant of beauty which lasted until autumn's colorful robe was laid aside for winter. Spring followed a gentle winter, with an abundance of rain and snow, which sent Oak Creek, Pecan Creek, and other little streams in the valley out of bank twice. The whispering song of rippling waters in Pecan Creek, and the lazy drone of bees working hurriedly in a mountain of white blossoms in a wild plum thicket in the bottom land was a melody of spring set in a riot of beauty. The snow white blossoms of the plum thicket were surrounded with a mosaic of greens from new leaves on chittum, hackberry, cotton wood, elm, willow, and grays and browns from fading winter. Carpets of wild gourds spread their yellow blossoms below the undergrowth in the bottom land.

On the prairie they sought refuge beneath thorny agerita bushes, spears of bear grass, and the sharp spiny spears of prickly pear as places for their vines on which to grow gourds. Their yellow blossoms competed with the color of buttercups and a generous variety of colors on nature's palette.

Mesquite trees waved lacy leaves in pastel shades of yellow-green. Mesquite grass added other greens, and in among the greens were scarlet from Indian-paintbrush, black and yellow from black-eyed-susans, the red and black of other wild flowers, white from the plumes of bear grass.

Dwelling in all this beauty were wild gourds, an innocent looking vegetable with green and yellow stripes resembling a miniature watermelon. But this innocuous looking vegetable was loaded with the most vicious chemical known to taste buds. A quantity the size of an atom, obtained from the gourd or its vine, would flavor from eight to ten gallons of milk. Suckling babes couldn't take the breast of a mother who had eaten butter or drunk milk containing a smidgeon of gourd liquid. During gourd season we could smell the breath of our cows a good quarter mile away.

I destroyed the gourd vines, but somehow the cows would find others. To make the milk problem seem more acute, we hadn't forgotten the dry years when we had little milk and bought peanut butter by the gallon. The wild gourd situation was similar to an experience a few years before with scorched lard.

I have never been a patient person and I paid for my impatience in a big way. It happened at hog killing time. Hog killing time had an air of celebration; the work was fun. One reason was the delectables of fresh liver, ribs, sausage, backbones, and crackling bread. Sausage grinding, souse meat making, salting

Lord and Master

63

down the meat, and rendering lard were some of the tasks involved, but they were never a burden.

Mother usually rendered the lard, but she was away with a sick neighbor, so I volunteered for the job. I had watched her in the process, so I began the task by building a slow fire around the wash pot. The cut up fat was boiling and blubbering about like some I had seen her cook, but I decided to improve her method. I placed more wood on the fire and soon the fat started popping and cracking and little geysers of grease began jumping out of the pot. I guess I didn't stir the fat enough for it began sticking to the pot and smelling like burned leather. I pulled the fire away, but too late, tragedy had struck. When mother rendered lard she placed the remainder of the uncooked fat into the sack and allowed the grease to drip back into the pot. The drip–dried dehydrated fat was called

cracklings, but usually went by the name of "cracklin." The cracklins which mother rendered came out of the pot in little brown strips. Mine were round and black. Mother used cracklins to make a form of cornbread called "cracklin bread." We looked forward each year for the delicious bread, but we missed the pleasure that year.

Mother and all the women in the valley baked biscuits, cornbread, and lightbread. It was customary when a new family moved into the neighborhood for one of the settlers to give the newcomer a start of yeast to be used in baking light bread. The "start" consisted of dough left over from the last baking of bread. If not used fairly soon it would lose its rising power.

During the year of scorched lard we had an abundance of currant and wild plum jellies, homemade sorghum syrup, fresh churned yellow butter and other sweets to go with the butter and lightbread and biscuits. Being a growing boy, my appetite was at its best and my requirements for such table pleasure were considerable.

The first biscuits that mother baked using the scorched lard weren't quite as bitter in taste as wild gourds, but it was a sad experience. Neighbors, hearing about our calamity, came to our rescue with various remedies to remove the scorched taste from the lard, one of which sounded pretty good, but didn't work out. We placed the lard back into the pot and added some charcoal and reboiled the lard. The charcoal absorbed some of the scorched flavor, but added its own. So, we had to live with the combination flavor until hog killing time next year.

After endless searching I destroyed all the gourd vines, but we had some other irritations in the milk department. Grass was full of water and had a tendency to loosen the bowels of our cows. Cockleburs were plentiful and a cow's tail had a tendency to gather the burs. It was a minor thing, but when milking it was maddening when an old cow would swing her tail across my face loaded with cockleburs, in particular if she had the sours.

Another aggravating thing developed in the milk situation which I guess was due to the easy living of the cows. They would go out in the pasture in the mornings, and in no time they would be so full of green grass they were ready to explode. Then, they would come into the cow lot in the early evening and stand around, chewing their cuds and trying to breathe. Their bags would be

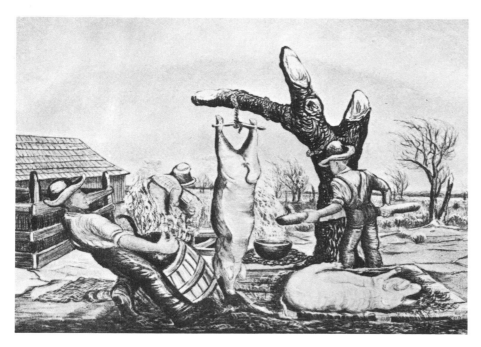

Gray December

hanging down to their hind leg joints, stretched so tight they would drip milk.

Maybe it was the overloaded udders that caused a problem which developed into a mystery. One day about sundown, when coming in from the field getting ready to milk and do other evening chores, I saw cows milling around the cow lot with flabby bags swinging from side to side as they moved. Then, in milking, I got only a gallon of milk from four cows.

This went on for a day or so, and then one day when I came in from the field much earlier, in passing the cow lot I saw an old cow leaning up against the fence with her calf's head poked through the fence, hunching for the last drop of milk. I placed extra strands of barbed wire on the cow lot fence but it didn't get the job done. The cows were determined to get rid of the milk one way or another, and in so doing violated bovine laws and nature's rules by allowing calves that had been weaned to give them relief.

In order to stop the foolishness I placed antisucking devices, blabs, on the calves. The blab was a tin contraption fastened onto the nose of the calf. It was fastened to a wire which pierced the calf's nose. When the calf lowered its head, the tin swung forward, allowing the calf to graze or drink, but when it raised its head to suck, the tin fell forward over its nose.

I bought a ready–made contraption with protruding spikes which pierced the cow's bag when the calf tried to suck. This device was placed over the calf's head like a bridle or halter. The store-bought instrument was used on calves left in the pen during the day while the milk cows were out grazing. This stopped the supper time milk giveaway.

The odds are possibly a million to one that all of this would stop the old cows in their determined ways, but it didn't.

In a few days we had cream for the man who came by on his route. We had plenty of butter to eat and skimmed milk for the hogs. Then, something happened which is almost unbelievable. Late one day when I was getting all set to milk, I saw an old cow with a contented look, but I remembered afterwards she wasn't chewing her cud. All at once, with one swift motion, she raised a hind leg, swung her head around and grabbed a teat and went after the milk.

Then I placed the spiked contraptions on the cows and bought

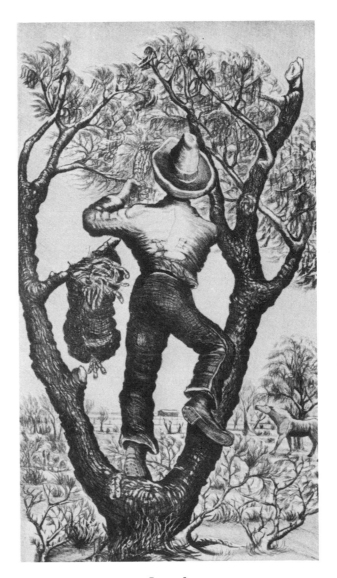

Leander

65

Drop Dusting

66

more for the calves. By the time I solved the milk problem I had enough antisucking devices to start a hardware store.

The next episode may sound more fantastic and is certainly not the cup of tea for finicky people.

Every time that I fed and slopped my thoroughbred big-boned Poland China sow, I counted my money. I had hopes she would have a litter of ten pigs, and with pigs of that kind bringing five dollars each, I would have a sum not to be sneezed at in those days.

One morning as I walked up to her pen holding a five gallon can of slop in one hand and a bucket of milo maize heads in the other, I saw a sight that knocked me for a loop. The old sow was bloody as could be from eating one of her new born pigs. I grabbed a weeding hoe and beat the daylights out of her and saved two pigs.

After the milk department became stable and after recovering from the shocking sight of the old sow, things got back on an even keel.

Cotton and milo maize were up to a good stand. Sunshine and rain came with the regularity of the tides which wait upon the moon. Cotton stalks rose to the warmth of the sun and turned their leaves to face its energy. Like the previous year, prosperity was smiling upon us; then, it began to frown. While eating breakfast we heard something thumping against the side of the house. Looking out the kitchen window, we saw hens chasing grasshoppers all over the place. In minutes the hens didn't have to chase the insects, for they were so thick all the hens had to do was to grab one and choke it down. The grasshoppers were in various sizes, from babies to some almost as big as a wheat-bird. The hens didn't bother the jumbo ones, for they were too troublesome to handle. I can imagine the hens thought they were dreaming or in chicken heaven, but they didn't take a chance on awakening, for they choked grasshoppers down until their craws were so stuffed the weight threw the hens off balance. The walked around with heads down and tails up, so full they couldn't cluck.

When the grasshoppers first appeared, our roosters, in order to gain favor with their lady friends, were very gallant and allowed the hens first choice. But in no time they got excited and stuffed themselves until they couldn't crow for several days.

Maggie and I knew that we were not dreaming; we grabbed towsacks and went into the cotton patch to do battle. For three

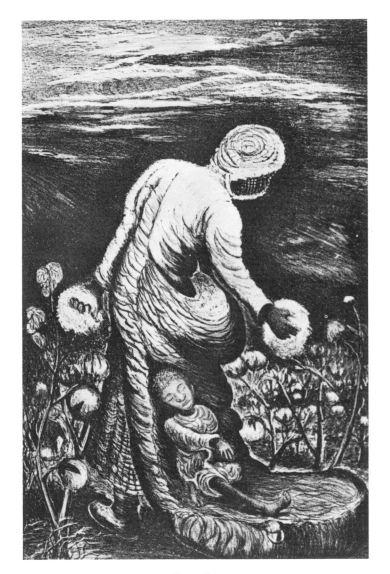

Devotion

67

days we walked up and down the cotton rows, swinging sacks, brooms, wooden paddles, and automobile inner tubes, swatting the hordes of grasshoppers, but they continued to come out of nowhere. I have always managed to get a little fun out of most anything—we had a little fun in hitting one of the jumbo size hoppers with wooden paddles. It sounded like a bat striking a baseball. We swatted so many grasshoppers that the tobacco-like juice from the insects plastered our shoes brown as we walked in the soaked earth.

We soon saw the battle was lost, and resorted to poison. We placed shelled milo maize in tubs, poured molasses over it and stirred arsenic into the sticky grain. We sowed the poisoned grain over the field, and finally won the battle, but the battle ground sure was a sad sight.

The once beautiful cotton leaves were left in shreds, some completely eaten away, leaving bare stalks. The battle left us with a real tragedy. We had two horses and two mares for work purposes, though only one horse had any sense at all. Sure enough, Henry, the good horse, in some way got hold of some of the poisoned grain and died. Charlie and the two mares had too much mustang blood and were hard to handle. It's a thousand wonders the critters didn't kill me. In order to corral them I had to tie trace chains to their halters. When they started running the swinging chains whipped their forelegs and slowed them down.

Sunshine and rain continued to bless the earth and its vegetation. The ragged cotton stalks put on new limbs and leaves. I used the mare to pull a cultivator down the cotton rows. They resented it and would slip from under their traces and turn around and face me while still hitched to the cultivator. I drove them down the cotton rows in a trot until they panted like lizards and dripped rivulets of sweat, and then they would run away with their harness on the way to the barn. I continued to plow the cotton in spite of the objection.

June 30, 1920 . . . I made my last plowing that morning, and as I drove down the cotton rows, stalks reached to the cultivator seat, and I laid it by. In order to celebrate I hitched the mares to a wagon, loaded two empty barrels into the wagon with which to bring back household water, and with my wife and boy, started for mother's to make ice cream.

As we started out the morning was sultry with big white boiling masses of thunderheads piling up across the sky. The big roaming clouds left an opening for the sun to cast its rays on our cotton patch, sparkling with pride in its lush beauty. This was the last look which we had as we rounded the corner of our cotton patch on our way. Later in the day we almost met our Maker at the same corner.

After arriving at mother's we had the ice cream almost frozen, with the freezer about to lock, when big thunderheads formed a giant stairway in the sky, clouds at the top turning to a dark green, angry streaks of lightning spearing into the clouds. We didn't need an expert to tell us the high green clouds meant hail.

Maggie and I reluctantly abandoned the ice cream, left our boy with his granny and Jess, and left without filling our barrels with water. We knew that our chickens wouldn't have sense enough to get under shelter, so we left in a hurry, thinking we could beat the hail to our house and save them. The mares seemed to sense danger. They certainly didn't need any urging; in fact, they were hard to hold down to a fast trot.

Soon flashes of lightning began streaking to earth, followed by claps of thunder, and every now and then the mares would break into a lope. Soon all the world seemed to be lighted with a constant flicker of flashes and streaks of lightning. Before we reached the gate to our rented farm the roar of approaching hail mingled with constant claps and booming thunder made it difficult for us to hear each other; however, we had little to say, for the air became stuffy, making it difficult to breathe, much less talk. The only talking we did was to the Lord. We could see a barrage of hail kicking up dust off to the right and marching across the prairie to cut us off from our house.

In the beginning the race was to save our chickens; now it was to save our lives.

Just as we drove through the gate, lightning split the universe wide open as it came to earth and demolished a cottonwood tree close by. The sizzling white streak and crashing boom of thunder sent the mares into a wild run. The empty barrels bounded out of the wagon and rolled and bounced down a draw, which was of little consequence. Maggie clung to the wagon and I held onto the lines as

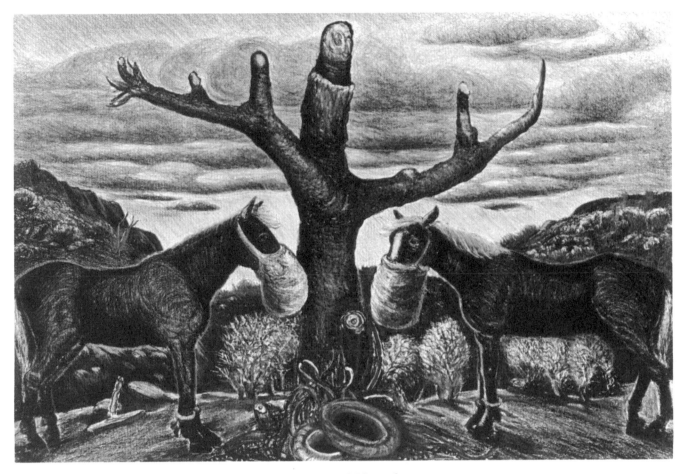

Hobbles and Morrals

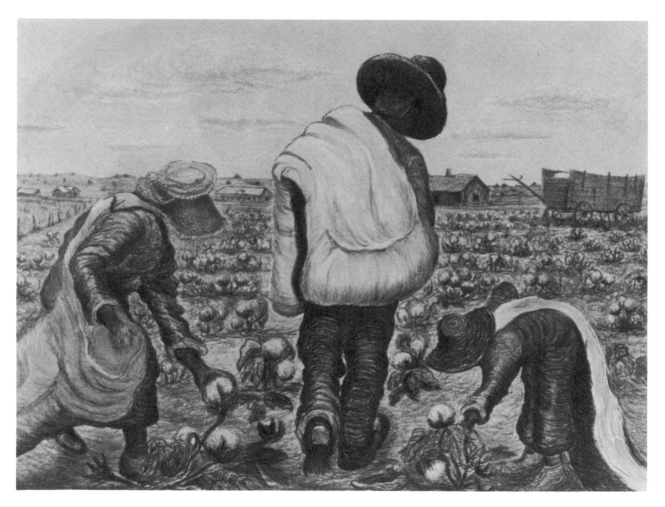

Bumblebee Cotton

70

Cotton Stalk

71

the wagon bounced and reeled in the pasture ruts. I tried to slow the mares down as we approached a right angle turn at the corner of our cotton patch, but it was of no use. Somehow we made the turn without the wagon turning over—how I cannot say.

After making the turn safely our next crisis was due to the fact that our barn was under a steep hill. I knew the mares wouldn't stop until they got to the barn, and if they ran down the hill only a miracle would save us. The barrage of hail kept gaining on us; its roar, accompanied with lightning, drove us into a state of shock. It was over a half mile from the beginning of their dead run to the barn, and, as we approached it, the mares began to slacken their speed, which was frightening, but possibly saved our lives. By the time we reached the decline to the hill, the mares' speed was reduced to an exhausted fast trot. The wagon careened and whipped from side to side as we slid down the hill.

Upon reaching the barn I stripped the harness from the mares and threw it on the ground, and we raced for the storm cellar. As we ran, hail stones were thumping the ground all around us, a few striking us, which we didn't realize until the next day when we found blue spots on our bodies.

When we reached the safety of the cellar and closed its door, hail was pounding the cellar door with maniacal fury. For what seemed hours we listened, downhearted with thoughts about the disaster. Finally all became quiet outside, thunder rumbling and growling on down the valley.

When we entered the cellar the day was steaming hot, but when we came out all outdoors was locked in winter–like cold. The wind had piled hail drifts around cedar bushes and other objects under which our chickens had sought refuge. We gathered a few and tried to revive them by warming them in our cook stove oven, but to no avail. Next day we gathered several hundred dead chickens from under bushes and other places and buried them. We didn't get an accurate count for we found dead chickens several days afterwards. We counted over five hundred. Jess had more time to save most of his Lone Star Poultry Farm chickens.

In looking over the damage to my cotton patch I saw stubborn cotton stalks, survivors of the battle with grasshoppers, shorn again of their golden promise by another enemy. Sunshine and warm wet earth began a healing process, and soon the wounded stalks formed

new limbs and leaves and began blooming again, but autumn was near. A late frost was our only hope for a crop of cotton.

By late October the cotton stalks held a good crop of blooms, squares and bolls, almost matured, and still no frost. Fall continued warm, geese were late in going south, leaves were slow in taking on autumn colors, a late frost was certain. We laid our cotton crop by for the second time.

Autumn mornings were beautiful. A veil of haze hovered close to the earth, hiding the blue skies of summer. The sun shone thin and golden over our cotton patch, bathed in morning dew. Anxiety about our cotton crop was lost as I listened to the cheerful notes of our roosters crowing, fieldlarks chirping, the ringing notes of bob whites in early mornings.

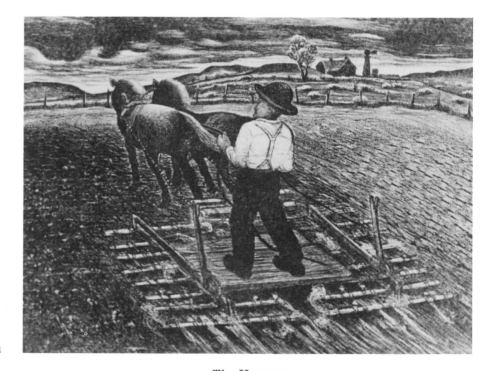

The Harrow

One morning the spell of autumn's charm was broken when I looked across my fine cotton patch and saw a web resembling that of a spider floating in the air, with some of the wispy web clinging to cotton stalks. Upon examination of the web I found millions of tiny worms in the mesh of the web and other millions of the tiny worms chewing on the underside of cotton leaves.

Army worms, the third enemy of the year, were attacking the stubborn cotton stalks. Again we went into battle. I rigged up a contraption on my cultivator with which to spray the cotton stalks. Our county agent, Mr. Calvert, furnished a formula of arsenate of lead and water which settled on the cotton leaves. The method which I used later evolved into one called "crop–dusting," in which airplanes are used.

In spite of all my efforts the army worms won the battle and left ragged leaves hanging limp on cotton stalks. Sunshine blistered the half–matured bolls and the battle ended.

I was tired of snakes, self–sucking cows, cannibalistic hogs, grasshoppers, army worms, so bade farewell to the farm. Another country boy moved to the bright lights of the city. Sweetwater became my home for seven years.

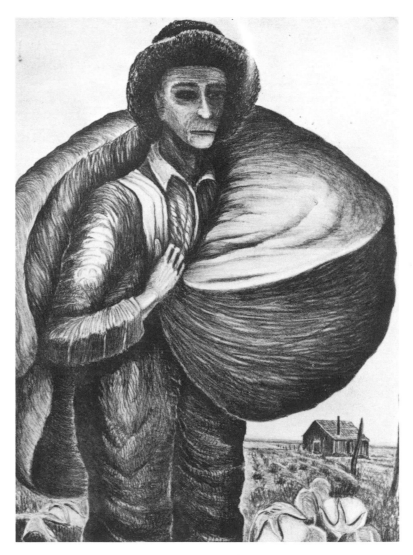

Vanquished

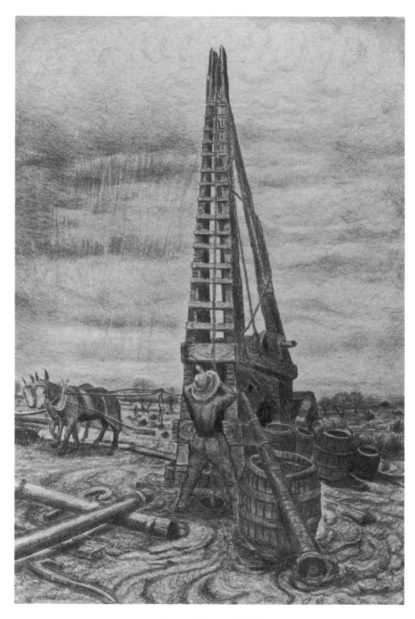

Dave Henry's Rig

74

14
The Artist—1927-1973

After leaving the farm, I spent seven years in Sweetwater working at various jobs, the first of which was keeping the storeroom for a construction company that was building a plant for the U.S. Gypsum Company. My last employment was with the Planter Gin Company, which operated a string of cotton gins and oil mills.

On July 15, 1927, with my wife and son, I moved to Dallas and went to work for J. Kahn and Company, cotton exporters. The threads in the loom of my life were slowly weaving, but the pattern was to come later.

During the fall of 1932, I enrolled in evening accounting classes at Bryan High School, now Crozier Technical High School. I soon found that accounting was my "thing."

In September, 1933, I enrolled in the evening classes at the same school, but in an etching class taught by Frank Klepper, and in a life drawing class taught by John Knott.

In the autumn of 1934, I again enrolled in the same art classes. It was then that a long dormant force burst its bounds, and art became the warp and woof on the loom of my life. I have never been able to extricate myself. The dream which began with old man Peck and grew a little during the correspondence course on the farm began to take on reality.

I was unable to attend the two art classes regularly during the winters of 1933 and 1934, but I managed to create 24 designs on copper, in aquatint, dry point and bitten line, and learned a lot about drawing from the eminent artist, John Knott, who was cartoonist for *The Dallas Morning News*. Several of my copper plate works concerned the cotton I was familiar with, and was the beginning of what later developed into a graphic record of rural life during the early part of the century.

I sketched in oils outdoors every spare moment, and painted at night, which resulted in two of my oils being chosen by a jury composed of three nationally known art authorities for the art show of the Texas Centennial of 1936. The acceptance set me forth on a dedicated journey.

With so much to be learned and with so little time to pursue knowledge, and with creative forces begging for expression, HURRY, one of my lifetime enemies, almost destroyed me physically. The terrific pace which I had set caused a duodenal ulcer to hemorrhage, but blood transfusions saved me from death; this had to be repeated in later years.

I wanted to live for a purpose and prayed for a few more years to fulfill the mission. In my petition I didn't realize that a creative mission never ends, for out of somewhere comes warp and woof to feed new designs into the loom of life.

I was unaware that the design of my life was forming on the loom, as I expressed twenty years later in the dedication in *Cotton Farm Boy*.

"That my mother's and father's names might stand for something good, creative and constructive, that the world might benefit by their having been here has been my daily prayer. This work is a small token in perpetuation of that ideal and prayer."

I have always been inclined to believe in predestination as expressed by Marcus Antonius.

"Whatever may happen to thee, it was prepared for thee from all eternity; and the implication of causes was, from eternity, spinning the thread of thy being, and that which was incident to it—"

In 1937, due to the organization of a number of artists into a group called Lone Star Printmakers, I found my medium. We each agreed to do at least two prints to be sent out on circuits which we did with success for three years.

I Would Come to Destroy, Not Save

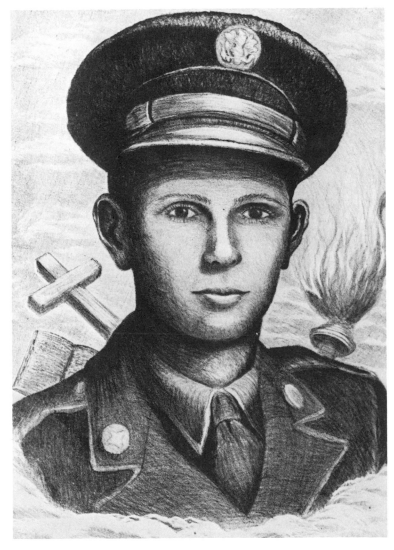

Merritt, Jr.

The following artists belonged to the Lone Star Printmakers: Alexandre Hogue, Reveau Bassett, Ed Bearden, Jerry Bywaters, Charles T. Bowling, Don Brown, Otis Dozier. E. G. Eisenlohr, William Elliott, Edmund Kinsinger, William Lester, Ward Lockwood, Loren Mosley, H. O. Robertson, Perry Nichols, Everett Spruce, Olin Travis, John Douglass, and myself.

I had experience in etching, but I felt copper would not allow my emotional bent its best expression. I knew that sweet delicate things, abstract or nonobjective expressions, were not my forte, for I felt my message required wider understanding and forceful execution. I knew that with all the discipline which I could muster my smouldering ideas would be hard to contain, so felt that the lithograph stone was the proper medium.

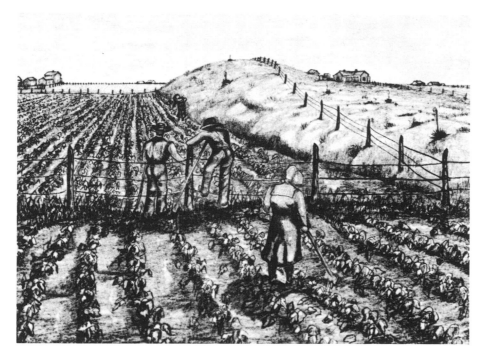

Crop Talk

I have always been and always will be a student in search of knowledge and this impelling force drove me in the study of lithography. After choosing my medium I sought knowledge, which wasn't easy, for it was younger than other black and white mediums, and I found very little written on the subject of how to do a lithograph.

Not having a lithograph press and stones, I created drawings on lithograph transfer paper and sent the drawings to Theodore Cuno, a master printer in Philadelphia, who pressed them onto lithograph stones and printed the drawings. Two of the paper transfer prints are: *Crop Talk* and *Grand Pa Snazzy*. The prints were the beginning of my cotton series, which grew into over a hundred small editions which I call "The Last Frontier of the Cotton Farmer."

I drew *Southern Memories* on an aluminum plate which had a drawing surface similar to the grained surface of a lithograph stone. I also sent it to Cuno, who printed an edition from the plate.

I found that drawings transferred to the lithograph stone coarsened in printing, and metal plate drawings lost many of their delicate values in the printing. This was forcibly drawn to my attention when I drew *The Lagow Place* on a lithograph stone and got my prints back from Cuno.

I then bought a lithograph press and some stones from Dorsey Printing Company, commercial printers, who had used the equipment in an earlier day. Then I soon discovered why the lithograph medium was not popular with artists, for printing the drawing on stone is a problem of great magnitude.

After a tremendous amount of effort, accompanied with heartbreaks, I printed close to 200 editions of lithographs which I saved, to say nothing of those thrown away. I also printed fifty or more editions for other artists, but I most certainly did not reach the state to where I considered myself a master printer.

This pace was kept up until 1940, when, due to the fanatical pursuit of my obsession, my health gave way and I had to give up my job with J. Kahn and Company, who gave me $100 a month until I was able to get another job. For the next three years I did odd jobs, printed lithographs for other artists, and some for myself. I taught the technique of drawing on the lithograph stone with

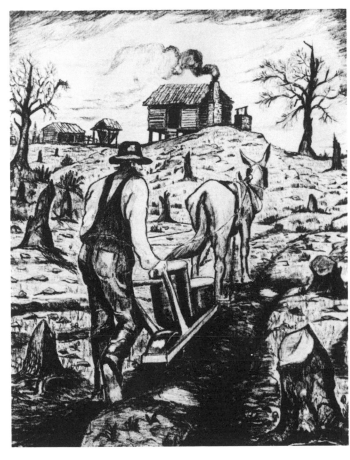

Grand Pa Snazzy

classes in my garage studio, and one semester at The Dallas Museum of Fine Arts.

Then, in 1943, I got, "out of the frying pan into the fire" as the saying goes, when I went to work for The Firestone Tire and Rubber Company in their retread shop. With the exception of a year's leave of absence during my Guggenheim year, I worked for the company until 1962. I worked a minimum of fifty hours per week, but due to some driving force I created six books and a number of drawings, paintings, and lithographs during that period.

I sketched outdoors on Sunday, drew, painted, and wrote at night. Many nights Maggie would come to my "rat den" as she called it, at one and two o'clock in the morning, and pull me into the house where I would sleep three or four hours and be on the job at 7:30 the next morning, ready for another ten hours. Due to the punishment which I gave myself I had to go to a hospital about every other fall with a bleeding ulcer.

Pumper's House

15
Books

All my books are unique in the fact that all illustrations in each book were created before the text was written. It came about this way. . . .

Before being awarded the Guggenheim Fellowship I had created a large number of small editions of lithographs, using the subject matter of rural life during the early part of the 20th Century, in particular that of the farmer and rancher during the time of transition from ranches to farms.

During August and September, 1946, while on the fellowship, I placed a number of drawings on stones at The Fine Arts Center in Colorado Springs, Colorado, where the master printer Lawrence Barrett printed the drawings at no charge to me, nor did the Center charge me. I gave the Fine Arts Center a lithograph from each stone. Adding the number which Barrett printed for me to those which I had printed in my studio, I wrote a text about each print and titled the story "Southern Symphony."

On May 11, 1947, I arrived in New York to spend a little over two months viewing art and in placing one drawing on stone in the Master Printers "Millers Studio," in Greenwich Village. I was still creating under the Guggenheim Fellowship. Upon my arrival in New York the first thing that I did was deliver "Southern Symphony" to McMillan, leaving my address and phone number. On July 2, Mr. Scott, the editor, called me and said that with 125 prints to reproduce and the large text it would be priced out of the market.

Upon reaching home from New York, I reworked the text with 85 lithographs and sent it to McMillan. Four weeks later it was rejected, stating that it would have to be published as an art book, and art books had limited sales. I then reduced the text further and submitted it to other publishers, from whom I received nice rejection slips. I then turned to that good man Samuel Golden, head of American Artist's Group, Inc., New York, who after reading the text and seeing the lithographs suggested that I turn it into a juvenile, which was a wonderful suggestion.

During all this time I had the good fortune of having a wonderful friend and gifted writer, Luise Putcam, Jr., who was at that time Book Editor for *The Dallas Times Herald*. Luise had a book of poems published, *Sonnets for the Survivors* and later two great books, *The Christmas Carol Miracle* and *The Night of the Child*, both classics. Luise had many stories published at that time, and others since.

While in New York, Luise met Henry Schuman, the publisher, and from her description of the book he became interested. On October 2, 1952, Mr. Golden delivered 75 lithographs to Mr. Schuman at 20 East 70th Street, New York, City, and returned my text to me. Luise rewrote the text completely, surrounding 50 lithographs, and in 1955, *Cotton Farm Boy* was published under the imprint of Henry Schuman.

The next five books were under the imprint of Abelard Schuman, Ltd. Using the approach set down by Luise Putcam, Jr., I had no difficulty in writing my own text for the next five books, which required very little editing by the publisher. To Luise Putcam, Jr., I owe eternal gratitude.

After *Cotton Farm Boy* was published I had enough art related to ranch life left to tie together with a short text; *Texas Ranch Boy* was born.

I had some first hand knowledge about oil, so began a search for further knowledge by getting information from oil companies, researching in the Dallas Public Library and from encyclopedias which I owned. After accumulating a mountain of material, I picked out highlights of the industry which held human interest, and drew pictures of the various subjects and tied the text and drawings into a continuous story about oil, titling it *Oilfield Boy*, under which title it was published.

The next three books, *Rice Boy*, *Rubber Boy*, and *Salt Boy*, required more research, but as before, companies connected with the industries furnished material and I added another source from information found in *National Geographic* magazines. After *Cotton*

Cotton Compress

Farm Boy, I limited my drawings to a little over 40 for each book; however, I created a surplus which I did not use in order to hold the story down to the publisher's needs. In each I used the same formula and made the drawings before I wrote the text.

* * * * * *

This is a small view of the whole, unfinished cloth. While the shuttle continues to weave, I close my notebook with some words from Thoreau's *Walden:*

"If man does not keep pace with his companions, perhaps it is because he hears another drummer. Let him keep pace to the music which he hears however measured and far away."

1897: Merritt Mauzey born, November 16, at Clifton, Bosque County, Texas

1916: Mauzey married Margaret Echols, July 8, 1916

1919: Mauzey's son, Merritt Jr., born, Blackwell, Texas, March 4, 1919

1936: "Mike's Ranch," Cotton Gin," oils, exhibited at Texas Centennial

1937: "Cotton Yard," "Cotton Gin," oils exhibited at Texas Division, Pan American Exhibit

Five oils sold to *Farm and Ranch* magazine, printed (color) as magazine covers: October, 1937; November, 1937; July, 1938; March, 1939; April, 1941

1938: Lithographs, cotton series, published in rotogravure, *Dallas Morning News*

"Cotton Gin," oil, exhibited at Golden Jubilee

"Mike's Ranch," oil, exhibited at Annual Oakland, Oakland, California

Lithograph, "To Distant Shores," exhibited, Southern Printmakers Circuit

1939: 10 Lithographs, purchased, framed, hung on trading floor by Dallas Cotton Exchange

10 Lithographs purchased, donated to Dallas Museum of Fine Arts, by W. A. Brooks, Jr., Vice-President, Farmers and Merchants Compress and Warehouse Co.

10 Lithographs purchased, donated to Houston Museum of Fine Arts, by W. L. Clayton, Anderson Clayton Cotton Co.

Print, "Grand Pa Snazzy," accepted and exhibited by International Print Show, Art Institute of Chicago, acquired by the Art Institute

One man show, oils, Delphic Studio, New York City

1940: "Good Earth," oil, exhibited, Golden Gate Exposition, San Francisco

One man show, Hockaday School for Girls, Dallas, Texas

Print, "Winter Southland," awarded Honorable Mention, Washington Watercolor Club, Washington, D.C.

1940: Print, "Southern Memories," acquired by Corcoran Gallery, Washington, D.C.

1941: Lithographs, cotton series, published in rotogravure, *Dallas Morning News*

"Cotton Yard," oil, exhibited at Texas Panorama, Gumps Gallery, San Francisco

1942: "Neighbors," exhibited by American Artists, 1914–1941. Whitney Museum, New York, Philadelphia Museum

Mauzey featured in *The Artist in America: Twenty–Four Close–ups of Contemporary Printmakers*, Carl Zigrosser, Alfred A. Knopf, New York; "Grand Pa Snazzy," "Prairie Ghost," and "Neighbors" reproduced in text; Zigrosser, Curator of Prints, Philadelphia Museum of Art, purchased the first 10 lithographs for this collection, which later grew to number 164 prints

One man show, Elizabeth Ney Museum, Austin, Texas; this exhibit was later moved and shown at San Marcos, Texas, and the Wittie Museum, San Antonio, Texas

1943: Lithograph, "Neighbors," shown at Town and Country Show, Art Alliance, Philadelphia, Pennsylvania

Mauzey elected to Connecticut Academy; Mauzey's work was represented in the annual exhibitions of this group, in Hartford, for several years.

"My Brother's Keeper," lithograph, selected for inclusion in "Artists for Victory" exhibition, jury show at the Metropolitan Museum New York City; this exhibit toured twenty-six cities; Mauzey's print was juried for donation to the Library of Congress; earlier, in 1940, another print was added to the Library's Pennel Collection; while on tour, editions of Mauzey's work (a total of 36 prints) were purchased at the Brooks Memorial Museum, Memphis, Tennessee, and at the University of Wisconsin

1944: Four prints ("Brothers") selected by jury for Bureau of War Information, included in graphics circulated abroad as cultural propaganda

"Brush Arbor," "Stormy Weather," "I Would Come to Destroy Not Save," prints, purchased by Metropolitan Museum, New York City.

"Twilight," oil, acquired by Pennsylvania Academy of Fine Arts

"Southern Memories" print and aluminum plate, selected for exhibition, Ashburn General Hospital, by Art Section, Camp and Hospital Council

1944: "Faith," oil, hung in Reception Center, New Zealand; the painting's present location is unknown

1946: Guggenheim Fellowship in Creative Lithography awarded to Mauzey; Mauzey, who had applied unsuccessfully for the Fellowship the year before, was notified of the award by his wife, Maggie, while at work at the Firestone retread shop, on April 10th.

1947: Mauzey elected to membership in Audubon Artists, Inc., and Society of American Graphic Arts

Mauzey's work was exhibited, by invitation, at the Carnegie Galleries, Pittsburgh, Pennsylvania

One man show, Grand Central Galleries, New York City

"Andrew Goodman," print, awarded purchase prize at Fifth National Exhibition, Library of

Congress; the print was thus acquired for the Library's collection

"Invasion," print, awarded Honorable Mention, California Society of Etchers, Gumps Gallery, San Francisco; Mauzey was elected to membership in the society.

"Andrew Goodman," print, awarded First Prize in graphics, Arizona State Fair

Biographical Article, "Sermons on Stone: The Lithographs of Merritt Mauzey," by Ruth Morgan, was published in *The Southwest Review* (Southern Methodist University Press) Vol. XXXII, Nr. 2, Spring, 1947; three of Mauzey's lithographs were published with the article

1948: Mauzey's work exhibited, by invitation, at the Carnegie Galleries, Pittsburgh, Pennsylvania

"Cotton Pickers," oil, awarded Second Prize in oils, Arizona State Fair

One man shows held at University of Nebraska, University of Wisconsin

"Andrew Goodman," print, awarded K.F.J. Knoblitz Prize by the Society of American Etchers, Gravers, Lithographers and Woodcutters, Inc.; the society's title was later changed to the Society of American Graphic Artists

"Invasion" and "Andrew Goodman," prints, exhibited in exchange show of American-New Zealand art; the American collection was assembled by Robert Wilson, Art Department, Texas Wesleyan College, Fort Worth

1948: One man show, Galeria de Art Mexicano, Mexico City

1949: Mauzey's work exhibited, by invitation, at Carnegie Galleries, Pittsburgh, Pennsylvania

1951: One man show, 38 lithographs with cotton as subject matter, Dallas Fair Park, Dallas Museum of Fine Arts (dedicated to Cotton Bowl Week)

1952: Reproduction rights to "Invasion" sold to Ginn and Company, publisher, for school text, *Your Life as a Citizen*

"Andrew Goodman," print, awarded Second Prize, Beaumont Art Annual, Beaumont, Texas

"Invasion," print, purchased by The New Britain Museum of American Art from exhibition shown there

"Invasion," print, included in *Prize Prints of the 20th Century*, selected by Albert Reese, published by The American Artists Group

Mauzey illustrated *The Land of Beginning Again*, by Julien Hyer, published by Tupper and Lovex

Martin Weisendanger of the Gilcrease Foundation and the University of Tulsa, presented 25 of Mauzey's lithographs, along with the artist's biography, over KOTZ-TV, Tulsa, Oklahoma

1953: One man shows, Beaumont Museum of Fine Arts, Texas Tech University, Lubbock

Biographical article, "Sermon on Stones," by Luise Putcamp, Jr., appeared in *Town North* magazine; a full-page reproduction of

"Tournemount Practice," along with other small graphics, accompanied the article in print

One man shows, Brooks Memorial Art Gallery, Memphis, Tennessee, Library of California, Sacramento

1954: Publication rights to "Brush Arbor" and "Brothers" sold to Houston *Post*, reproduced in 70th anniversary edition, January 30, 1954

"Neighbors," print, included by The Society of American Graphic Artists in exchange exhibit with the Royal Society of Painters, Etchers and Engravers of England; the show opened September 14, 1954, at the W. S. Galleries, London

First purchase of Mauzey's art by Dr. Irvin Kerlan for his collection of children's literature and art established at the University of Minnesota; by the time of his death in an automobile accident in 1963, Dr. Kerlan had acquired 142 of Mauzey's graphics for the collection

1956: "Milo Maize," lithograph, awarded the Belle Weedon McNeer Prize; the print was acquired by the John Taylor Arms Memorial Collection of the Metropolitan Museum, New York City; "Invasion," print was presented by the Society of American Graphic Artists to the Warren Mack Memorial Collection, Pennsylvania State University.

One man show, Texas State College for Women, Denton

1958: "Brothers," print, presented by the Society of American Graphic Artists in memory of Benton Spruance

1961: "Invasion" included in Contemporary Graphic Arts Overseas Exhibition; the exhibition opened at the Free Library of Philadelphia

1963: "Brothers," print, exhibited through South America as part of a collection shown by the Society of American Graphic Artists

1964: Mauzey's work accepted for showing in open national exhibition of the Print Club of Albany (Biennials), New York

1965: "Invasion," and "Neighbors," prints, included among collection, in memory of Arthur W. Heintzelman, presented to the Boston Public Library by the Society of American Graphic Artists

1966: Mauzey's work accepted for showing in open national exhibition of the Print Club of Albany (Biennials), of American Graphic Artists

"Brush Arbor" and "Circuit Rider," prints, published in *Methodism Marches Across North Texas*, Abdingdon Press.

"Neighbors," "Brothers," "Prairie Ghost," "March Winds," "Good Earth," "Plainsman's Dream," "Winter Southland," prints, presented by United States Department of State, Art in Embassies Program, to US Embassy and Chanceries, Karachi and Rewaldpini, Pakistan

1966-7: "Brothers," print, published in *Texas Almanac*, published by A. H. Belo in 125th Anniversary edition, *Dallas Morning News*

1967: 60 Graphics exhibited by invitation at University of Maine during October and November; this collection was then shown on a circuit that included: Moorhead State College, Minnesota, Fine Arts Center (Rochester, Minnesota), Four Winds Gallery (Kalamazoo, Michigan), Birger Sanzden Memorial Gallery (Lindsborg, Kansas), Columbia Museum of Fine Arts (South Carolina), University of Tulsa, University of Texas, Mazure Museum, (Monroe, Louisiana), Washington County Museum of Fine Arts (Hagerstown, Maryland), Columbus Museum of Fine Arts and Crafts (Columbus, Georgia), Museum of Fine Arts (Montgomery, Alabama)

1968: Maggie, Mauzey's wife of 52 years, died, September 6

Mauzey's work accepted for showing in open national exhibition of the Print Club of Albany (Biennials), New York

Friends of the Nicholson Memorial Library, Longview, Texas, purchased drawings used in *Oilfield Boy* for donation to the library's collection; the University of Southern Mississippi Library purchased drawings used in *Rice Boy*, *Rubber Boy*, and *Salt Boy*

1969: Mauzey toured ten countries in Western Europe; June Keller, daughter of a Swiss diplomat, Mauzey's tour guide, purchased numerous graphics for her collection and for presentation to friends in Austria and Switzerland; numerous tour sketches by Mauzey were later acquired by the library of the University of Southern Mississippi

One man show, Dawson's Decors, Cactus Alley, Lubbock, Texas

One man show, South Plains College, Levelland, Texas

"Invasion," "The Lagow Place," "Neighbors," "Brothers," "Nugent's Homestead," "Trip to the Gin," "Milo Maize," and "Cotton Wagon," acquired by the Pennell Collection, The Library of Congress

One man show, Museum of the Southwest, Midland, Texas; the museum purchased 75 graphics which were added to the 55 Mauzey graphics previously purchased for the collection there

Mr. and Mrs. Charles D. Clark, McAllen, Texas, presented 100 lithographs to the museum of the University of Texas at Austin; Mauzey donated 30 of his graphics to the museum in memory of his wife, Maggie

46 graphics acquired by the University of Maine

75 graphics acquired by the National Collection of Fine Arts, Smithsonian Institute

37 graphics acquired by the Birmingham (Alabama) Museum of Fine Arts

3 graphics acquired by the Birger Sanzden Memorial Gallery, Lindsborg, Kansas

5 graphics acquired by the Addison Gallery of American Art, Andover, Massachusetts

23 graphics acquired by the Colorado Springs Fine Arts Center, Colorado Springs, Colorado

22 graphics acquired by the New Britain Museum of American Art, New Britain, Connecticut

1970–1971:

April, 1970, Mauzey was cited for distinction in his career by the West Texas Chamber of Commerce

Bridwell Library, Southern Methodist University, acquired 99 Bible illustrations

Friends of the Nicholson Memorial Library, Longview, Texas, purchased 30″ × 40″ oil, "Texas Three Kings," for presentation to the library

Honolulu Academy of Arts purchased 33 graphics

National Museum, Warsaw, Poland, acquired five graphics through the United States State Department; these were added to two given previously to the collection, illustrations of poems by Poland's National Poet, Adam Mickiewicz; Mauzey's illustrations of the poems "Nixie" and "Faris," were widely exhibited in Poland during the centenary of the poet's death held in 1955

One man show, Public Library, McKinney, Texas; the library purchased "Offat's Bayou," a lithograph colored by Mauzey after printing

Mauzey made tour of Iron Curtain countries (1970)

Mauzey made world tour (1971)

1972:

Mauzey toured East Africa

"I Would Come to Destroy Not Save," print, presented by Mauzey and Society of American Graphic Artists as memorials to Sheldon Memorial Art Gallery, University of Nebraska (memorial for Thomas Coleman), Columbia Teachers College, New York City (memorial for Federico Castellon), and New York Public Library (memorial of Adolph Dehn)

Friends of the Nicholson Memorial Library, Longview, Texas, purchased 81 lithographs; Mauzey donated 20 in memory of his wife, Maggie

"Invasion," "Prairie Ghost," "Milo Maize," "To Distant Shores," "Winter Southland," lithographs, bequeathed as part of his collection to Southern Methodist University by Calvin Holmes

Dr. William Potts purchased 1 drawing, 2 outline drawings, 10 lithographs colored after printing, and 97 black and white lithographs

Whitney Museum of American Art, New York, purchased "My Brother's Keeper," "Stormy Weather," "Neighbors," "The Lagow Place," and "Trip to the Gin"

Women's Division, Chamber of Commerce, Lubbock, Texas, purchased "Tail Him Up," "Adam's Ale," "Snubbing Post," and "Bill Kitchens, 1917"

"Snubbing Post" and "Bill Kitchens, 1917" reproduced in *The Cowboy in American Prints*, John Meigs, Sage Books, The Swallow Press, Chicago

Dr. William Potts purchased three oils, "Olsen's," "Offat's Bayou," and "Mesquito Fleet"

First National Bank, Lubbock, Texas, purchased oil, "Winter Southland"

Dr. and Mrs. T. J. Beene, Jr., purchased oil, "Offat's Bayou," at auction

Texas Tech University Museum purchased 121 graphics for permanent collection

The Port of Galveston purchased 5 lithographs for use as cover for magazine

Whitney Museum of American Art, New York, purchased 5 lithographs

Catalogue of the Merritt Mauzey Collection published, University of Southern Mississippi

1973: University of Houston Museum purchased 100 graphics; Mauzey donated 10 in memory of his wife, Maggie

The Cotton Digest purchased 9 lithographs for use as covers for the magazine

Edith McRoberts purchased 65 graphics

Bridwell Library, Southern Methodist University, purchased 112 graphics

Thomas Gilcrease Institute of American History and Art, Tulsa, Oklahoma, purchased 47 lithographs

West Texas Chamber of Commerce presented "Brothers" and "The Lagow Place" to the Amon Carter Museum of Western Art, Fort Worth, Texas

Merritt Mauzey died, Dallas, Texas, November 14, 1973